Dynamic Watercolours

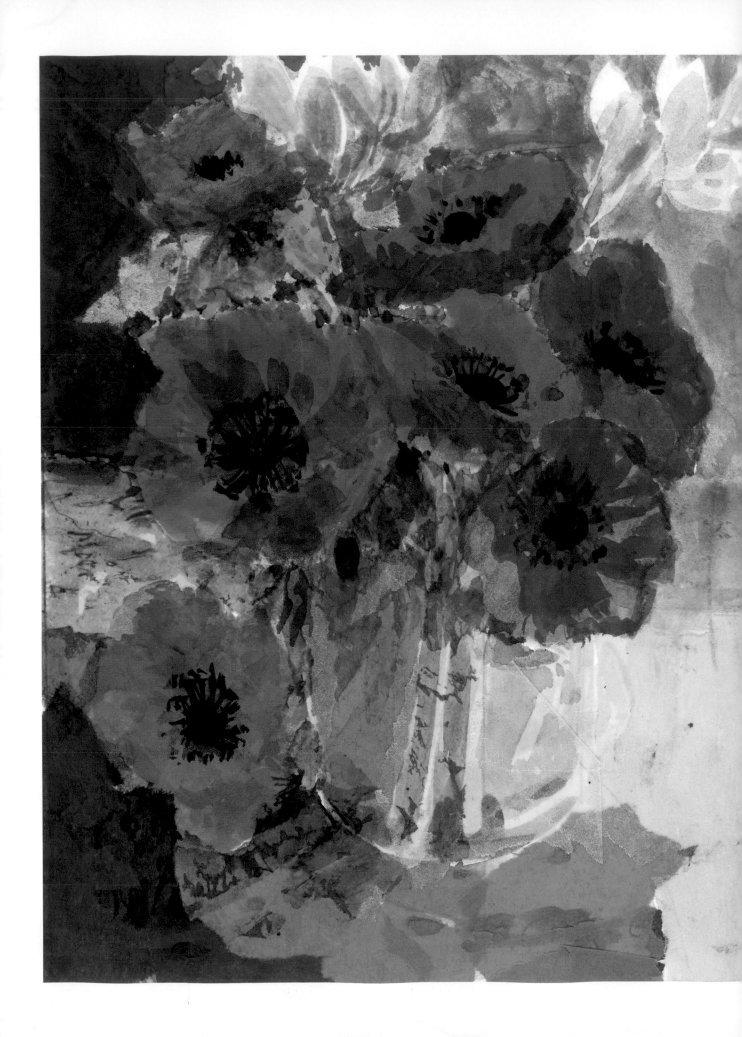

Dynamic Watercolours

Linda Birch

Bring movement and vitality to your paintings

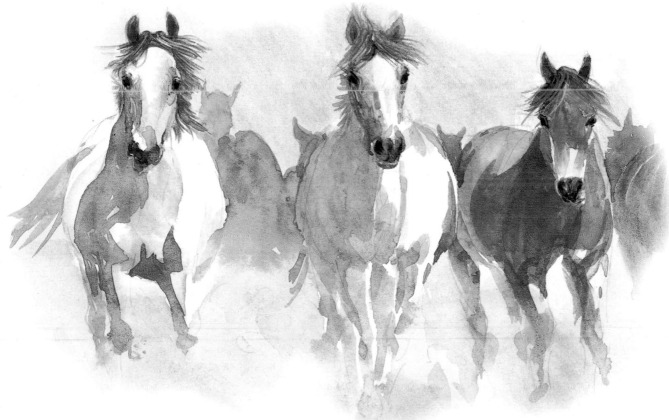

David & Charles

DEDICATION

Dedicated to Dick Croucher and Peter Lucas,
who encouraged and showed me the way.

A DAVID & CHARLES BOOK

First published in the UK in 2001

A catalogue record for this book is available
from the British Library.

ISBN 0 7153 1180 8

Printed in Italy by Milanostampa
for David & Charles
Brunel House Newton Abbot Devon

Publishing Manager Miranda Spicer
Project Editor Fid Backhouse
Designer Maria Bowers

Contents

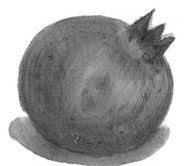

Introduction

Marrying the words 'dynamic' and 'watercolours' may cause a few raised eyebrows – but if you choose to follow the advice and suggestions presented in this book, I believe that the creation of more dynamic watercolours is precisely what you will be encouraged to achieve. If you want the real satisfaction of improving your work and making it stand out, you should be consciously seeking more dynamic results – not only in the literal sense of incorporating additional life and movement (though that is certainly part of it), but also by injecting energy, ambition and new ideas into your painting. The objective is simple – you must try to make people stop and notice your pictures, by mastering techniques which capture the viewer's eye and demand attention. Be prepared to try new things and explore alternative methods. Don't assume that your first thought is necessarily the right thought. Before

starting a picture, think carefully and decide if there might be a better treatment – another, more interesting way of tackling the subject. Try incorporating various different media into your work. Some experts will always insist that nothing should ever be added to 'pure' watercolour, for fear of compromising its integrity. But my experience suggests that the judicious use of black or coloured inks, watercolour pencils, coloured pencils, gouache and other imaginative options like collage can enhance your work without compromising the essential beauty and character of watercolour painting. So make the effort to familiarize yourself with the incredible range of dramatic effects that can be created when you understand – and skilfully deploy – colour itself. Attitude is all. Remember, any painting that fails to get the artist's message across will be unsatisfactory, even if it is brilliantly executed. Approach your work with the

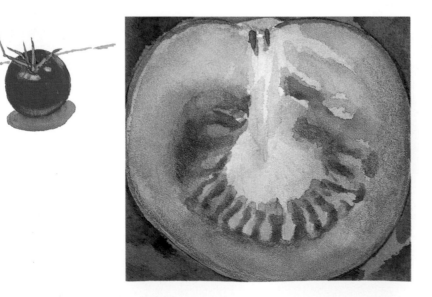

The unexpected

Why not interpret a subject in an unusual way for dynamic impact? Here the eye receives twin surprises, with the cross-section view and an object normally seen as small framed to look large.

Movement

The alternative versions of this trotting horse illustrate the way in which the use of imagination and advanced technique can turn an ordinary picture into something altogether more dynamic.

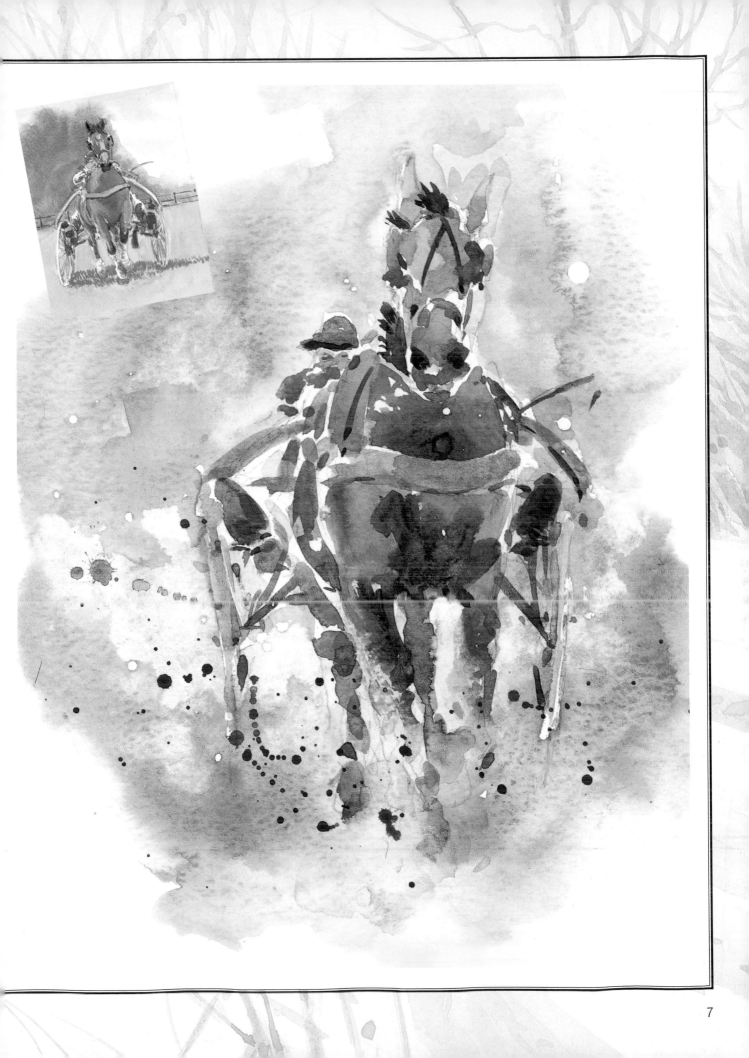

eagerness (and courage) to reject perceived wisdom and break the rules occasionally. Take nothing for granted. Decide to experiment constantly, without being put off when something doesn't quite turn out as expected, or you make the odd depressing mistakes (you will!). There is no magic formula which guarantees better pictures, but I hope this book will offer positive guidance that inspires you to try. Practise the ideas on these pages. Modify them. Trust your own judgment when you find something that works well for you, even if it's unconventional. Every picture you paint will increase your experience, and with relevant experience comes growing confidence. That is the key. If you start believing you have it in you to paint the sort of dynamic watercolours that always attract favourable attention, the chances are that you can . . . and will.

Linda Birch

Linda Birch

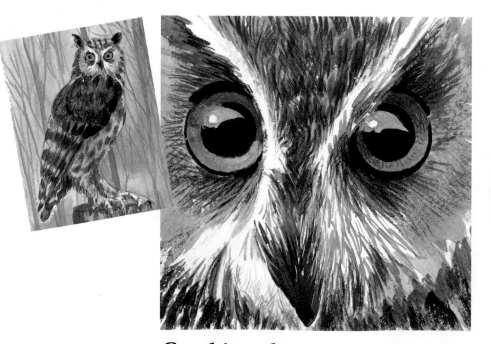

Catching the eye

Part of the subject can sometimes be much more exciting and dynamic than the whole, capturing the viewer's attention and forcing a response.

Atmospherics

Consider the possibilities of creating a powerful atmosphere that influences the viewer's mood – just look at the difference between these alternative views of an old farmhouse in winter.

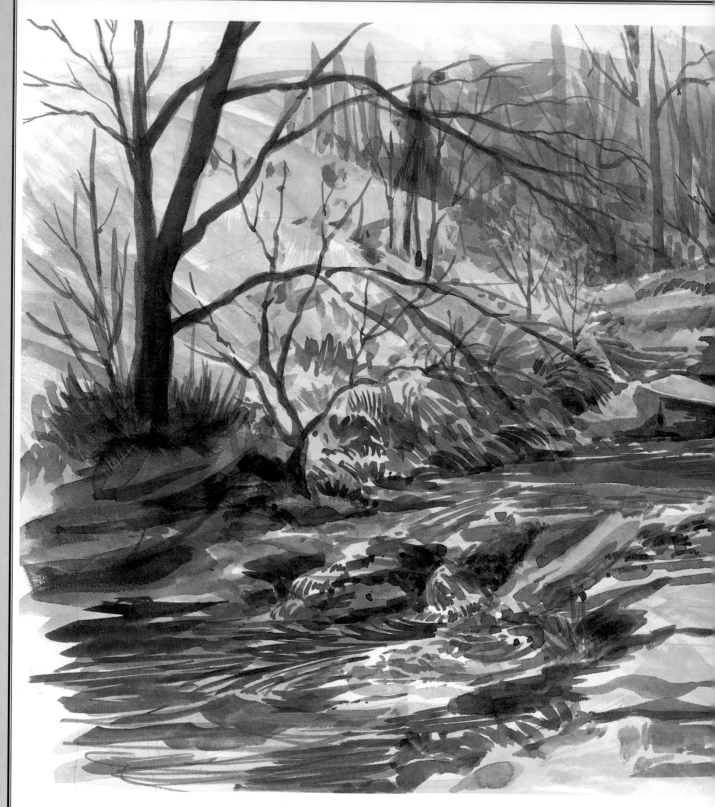

Spring waterfall

This vibrant scene was irresistible. Simple washes could never have captured the restless energy of the tumbling stream's rushing water, atmospheric background trees or the intricate detail of bankside foliage and overhanging branches. I used a number of advanced techniques to paint this lively picture – and will demonstrate how a whole range of exciting effects, used individually or in combination, can add new energy and excitement to your work.

Dynamic techniques

Watercolour is often seen as a process involving little except washes, but these are only part of the story of painting in this flexible medium, which can richly reward those who are prepared to use their imagination and experiment with advanced techniques. From the use of painting tools such as sponges or twigs through alternative papers to interesting additives and mixed media – you can achieve striking results in combination with washes or, more adventurously, by replacing them altogether.

Go with the flow

Some subjects are naturally dynamic, like running water. But this very fact can prove daunting for artists lacking the experience or technique to tackle fast-moving subjects with confidence. However, it's worth persevering – the end result can be both dramatic and satisfying.

Brushing up

Although it is tempting to buy a wide selection of brushes, you will never find a 'wonder brush' that can transform your work from competent to intriguing. A daunting number of brushes is available, but you actually need only a few in order to paint well. Many painters manage happily with only three. For the minimalist brigade, I always recommend these: a 'mop', the large, soft brush that is used for putting down washes over large areas (like a No. 14 or even an old shaving brush); a medium-sized, rounded brush for general work (No. 6, 7 or 8); and a small brush for detail (No. 2 or 3). When replacing your favourite brushes, it may be necessary to look around for an exact match – one maker's No. 8 may not be the same as another's, because brush sizes are not standardized. Nothing can quite equal the performance of brushes made with natural hair (the best are from the sable, a relative of the marten), but these tend to be expensive. Today's synthetic alternatives are almost as good in terms of durability and their capacity to hold liquid. If you have already started painting, you will have a basic collection of brushes. For those who wish to expand their capabilities and tackle more ambitious techniques, I would suggest experimenting with a wider range of brushes. The key to creating more dynamic work is finding the confidence to express yourself freely and the imagination to explore new techniques. I have chosen an additional six brushes that, used judiciously, really can help you to produce some fascinating and rewarding results.

New brooms

The **hake** (pronounced ha-kay) is a Japanese goat-hair brush that holds a lot of colour. I use this all-rounder a lot when painting landscapes. The bold **flat brush** is ideal for marking buildings and straight lines, and is also good for grasses, trees and foliage. The **filbert** – shaped like and named after the hazel nut – is excellent for experimenting with wash effects. Once a signwriters' brush, the **rigger** was 'borrowed' by artists for depicting ship's rigging and is now used for any fine-line effect. The bamboo-handled **Chinese brush**, originally designed in China for calligraphy and painting, is a practical alternative to the soft-pointed squirrel-hair brush used for twigs and branches, or fur and long hair. As the name suggests, the **sword** is a brush that resembles a blade with an angled edge, that works well for trees and foliage.

Hake **Flat** **Filbert** **Rigger**

Reach for the clouds

It only took a moment to capture this moving cloud formation on a breezy afternoon. You might normally use your standard wash brush for a similar painting – but why not try the exercise with different brushes and compare the results? I actually decided on a hake brush for this, but might equally well have opted for my soft haired filbert that retains paint so well.

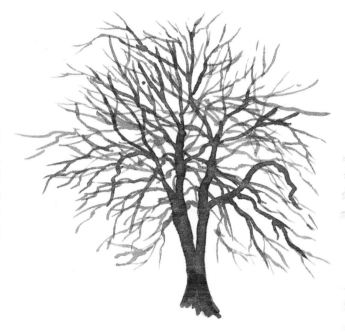

Trees please

The sight of dramatic winter trees often excites the artist, but the painted result can sometimes appear rather stilted and disappointingly solid. To avoid that 'static' look, I chose a rigger for this study. The fine tip makes it a favourite for detailed plant studies, but in this case I used the rigger's sensitivity to create a fluid three-dimensional effect.

Chinese **Sword**

Building the picture

I don't know how long it took to construct the old barn near my home, but it only took a few minutes for me to record this snow-covered scene. I used my flat brush (sometimes called a square-end), because it enabled me to build the picture with strong, decisive marks. The result was effective, illustrating the virtues of painting boldly and freely, without becoming bogged down with fiddly detail.

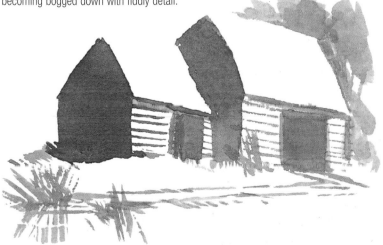

Making your mark

Prehistoric cave painters did not have the use of modern brushes, but still managed to produce wonderfully evocative images that have stood the test of time. We can learn from their creative ingenuity. Brushes are not the only method of applying watercolour paint onto paper. An amazing variety of objects can be pressed into service, and it is possible to have great fun experimenting with something completely different.

You might be surprised and delighted by the eye-catching effects that can be achieved. I will start you off by mentioning some of my own favourite 'alternative' painting tools, although the best part is actually discovering your own. While nothing can ever quite rival the simple beauty of pure brush washes, this is not the most dynamic of techniques. But don't forget that to create a dynamic picture it is not necessary to think only in terms of

conveying overt movement. The use of a different painting tool can achieve an impact that is dramatic – say by conveying extreme contrast or portraying a special texture. But be careful – the drama can be lost if such techniques are overused, by repeating them in too many pictures or even using the same technique excessively in a single image. The trick is to add a little 'something special' that lifts your work above the norm.

Start sponging

A sponge is the perfect – if conventional – starting point for those intent on broadening their options. Many watercolour artists use sponges to add quick impact to their work. I employed a sponge to create an 'instant' autumn foliage effect (below), then 'sponged' the forest vignette (left) to show what a powerful technique sponging can be, especially for adding dramatic highlights to a conventional wash treatment. Other effective uses of the sponge are, for example, adding lichen to stone or creating the distinctive markings on animal coats – anything where the addition of a striking texture will give the picture a dynamic lift.

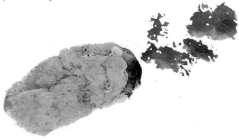

Waxing lyrical

The secret of success lies in making a picture stand out. This test strip was made by applying candlewax to the paper before painting. This created a resist, which is ideal for textured highlights. But you must be precise – once applied, the candlewax cannot be removed.

Twig this

I often think that the most successful watercolourists are those who understand the importance of that old saying 'less is more' and, when appropriate, have the courage to apply that maxim to give their work a true sense of freedom. Some of the most dynamic pictures I have ever seen (or painted) involved the use of an absolute minimum of paint, allowing a simple but compelling image to speak for itself. I used a twig dipped in watercolour to create the tree pictured right, and feel the informal result has real energy. Twigs are also useful for adding fine lines such as window details. They come in all sizes, don't cost a penny and make excellent substitutes for pens.

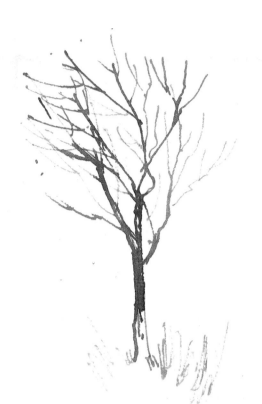

TEACHER'S TIP

When painting with a twig, you will need a container for your watercolour, so you can 'dip' the twig like a pen into an ink bottle. I have found that the ideal container is an old film canister with a snap-on top. Twigs can be used 'as found' with ragged ends for interesting effects, or sharpened and used like a pen for precisely detailed fine work.

Hands on

Many a first encounter with art will involve primary school finger painting – and this tactile technique should remain a part of every watercolourist's repertoire. Use a finger or thumb to create textural interest. I 'fingered' the fleece texture of this sheep, and have used the method for dappled markings on a horse's coat. For extra impact try ink on top of watercolour: you're seeking anything that gives your work that dynamic 'added effect'.

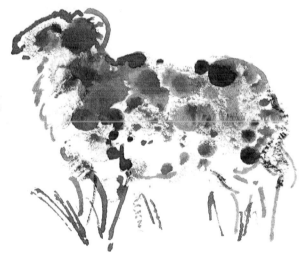

Nailing detail

Another useful detail effect can be created by using a nail – the one on the end of a finger if it isn't bitten, otherwise use one borrowed from the workshop. The divisions within the cups of these field mushrooms were made by scraping the lines with a fingernail while the paint was still wet. Experimentation with this technique can produce unusual textural effects that will really help a painting stand out.

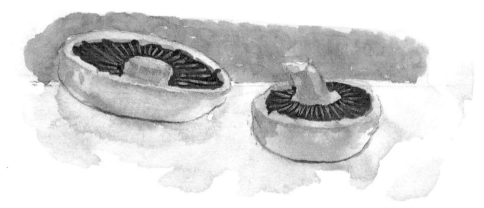

Knife work

I can't say it often enough – the whole point of
using alternative painting tools is to create
'special effects' that compel attention and lift
your work above the ordinary. One of my
favourites when it comes to injecting a sense of
dynamic energy into a picture is a sharp craft
knife, which is used to score lines in dry paint
as shown in the samples (below and below
right). This is particularly effective in imparting
the feeling of reflected light and movement
to the surface of water.

Wild cards

Oil painters have palette knives to produce
powerful colour effects. The watercolour
painter can use humble card for similar
results. I used an old credit card to create
this bold seascape, applying paint thickly
before spreading (as shown below) and
working it with the edge and corner of
the card until I was satisfied with the
dramatic quality of the image. The
original is a large picture, allowing
me to gain maximum
impact from
these broad
'cardstrokes'.

Material benefits

Almost any fabric – linen, cotton, silk, lace – can be used as an alternative to brushes. Experiment with different fabrics. Wrap material around a finger and dip into colour, or bind around an old paintbrush or stick to make a more permanent tool. The beauty of this technique is that it creates wonderfully rich, dense textures that make for very distinctive pictures. I used hessian to 'fabric paint' these sunflowers.

Masking time

Some techniques allow you to attempt worthwhile subjects that would be difficult or even impossible using normal methods. To paint this roadside cow parsley against the heavy background, I used masking fluid – a quick-drying latex solution. I 'painted' the plant in masking fluid before adding the hedge, then removed the latex using a small ball of dried masking fluid (a tissue or eraser will also do the job). The latex protected my masked area from the background wash, allowing me to achieve a finish that was both detailed and delicate when I completed the plant, which really stands out.

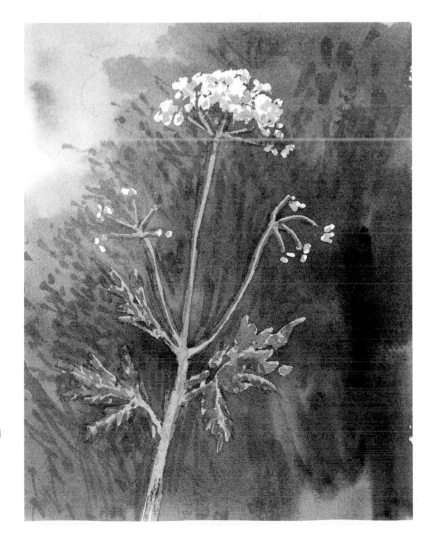

Playing with paper

It would, of course, be quite ridiculous to describe yourself as a watercolour 'paperer' rather than a watercolour painter – but the description isn't as silly as it sounds. In determining the final impact a finished watercolour will make on the eye, paper is nearly as important as the paint you put on it. The paint-holding qualities and surface texture of the paper will have significant influence on the type of painting produced. In broad terms, there are three 'finishes' you will find essential to the development of your skills (rough, medium and smooth). I have demonstrated the 'paint-upon' qualities of each on the opposite page. There are all sorts of specialist paper options available, too, including tinted papers. Although watercolourists have become accustomed to using white paper to gain maximum effect from transparent paints, watercolourists of the past used papers of many colours. The great Turner, for example, favoured silver-grey. I mention this to make perhaps the most important point on the subject of paper choice: there aren't enough pages in this book to examine limitless combinations of the different watercolour techniques with every one of those alternative papers – a wet-into-wet painting of a landscape on rough white paper will look completely different from the same scene painted using the same method on smooth cream paper . . . and that is just one permutation among thousands. So the point is this: when setting out to make your work more dynamic by employing some new, different and exciting techniques, it's crucial to bear in mind the major contribution that paper choice will make to the finished picture. Make experimentation with different sorts of paper an essential part of the creative process.

Weight for it

To the choice of paper types best suited to your various needs (a selection of watercolour papers is shown below) must be added the consideration of 'weight'. Paper classification is in old-fashioned pounds (lb) or grams per square metre (gsm). Lightweight watercolour papers start around 150gsm (72lb). Medium papers weigh in around 230gsm (110lb) and the heavyweights go up to 600gsm (300lb) or more. Anything over 200gsm (90lb) will absorb water slowly enough to let you work on your washes for several minutes. Anything lighter may dry faster and consequently 'cockle' (wrinkle).

Paper options (left to right): tinted Bockingford; smooth hot-pressed; blue pastel; rough hand-made; grey hand-made; white Not; brown pastel.

Rough paper

Cry freedom – because that's the feel you'll create by painting on rough paper, as these clouds show. The paper's dimpled texture adds strength to a composition and causes washes to behave unpredictably as they flow freely around these irregular 'obstructions'. Rough paper can stand considerable punishment from vigorous (and therefore expressive) brushwork.

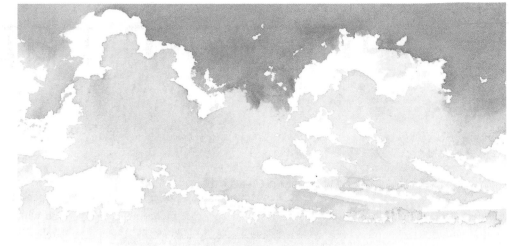

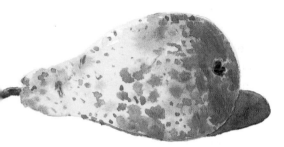

Smooth paper

I chose this pear to show the strengths of hot-pressed (HP) paper, a smooth paper that allows you to create very distinctive and fine effects. Because colour tends to stay on the surface rather than being absorbed, you can push colours around fluently to achieve soft bleeds and good detailed finishes like the pear skin. This paper is almost a 'must' when it comes to line and wash work.

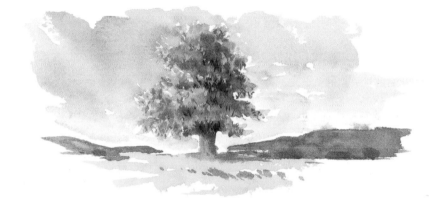

Toothed paper

This is a typical wash picture painted on medium-toothed Not paper – perhaps the best all-rounder in the watercolour paper team. This is also known as cold-pressed (CP) paper. It provides good texture effects and allows washes to spread well, without taking on a mind of their own. I use Not paper for much of my work.

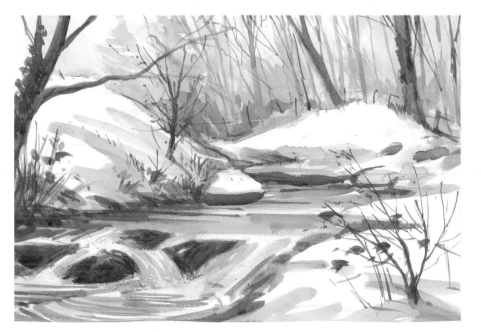

White paper

To demonstrate the importance of white paper in watercolour work, I painted this winter scene (another version is at the beginning of the chapter, showing how different the same place can be made to look). Not only does the white paper reflect light back through paint to give translucence, but it also serves as the lightest (and 'whitest') part of the painting, often with little or no colour added. In this picture, areas have been left unpainted to represent snow, while even the muted colours seem to glow in contrast with the white paper.

Wet-into-wet

If there is one thing that makes a watercolour stand out, it is atmosphere – and if there's one technique many watercolourists love to use when painting an atmospheric picture, it is wet-into-wet (sometimes called wet-in-wet or wet-on-wet). This method produces soft, melting skyscapes and chiaroscuro-like effects in landscapes, with an uncanny ability to capture the weather in all its moods. Try experimenting with a limited colour range – you might be surprised by the powerful atmospherics that are possible, as the lake view on this page shows. Wet a good, heavyweight paper, then drop colour on with a brush. As the colour starts to spread, tilt the paper until you're satisfied with the effect. Add another colour and repeat the process. Allow colours to bleed and mix. You can create wonderfully free textures with wet-into-wet – on occasion a bit too free. The diffusion of paint is not always easy to control and the final outcome can be unpredictable, but if you have the courage to persevere and master this dynamic technique, inhibitions can be cast aside and truly rewarding results achieved.

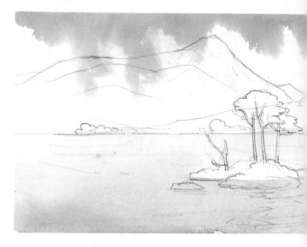

1 I drew the outline with a B pencil, making sure th waterline was straight, and wetted the paper. The water was a graded wash of cobalt blue. The sky effect was created by dropping on Winsor blue and cob blue and allowing them to diffuse, leaving white clouds

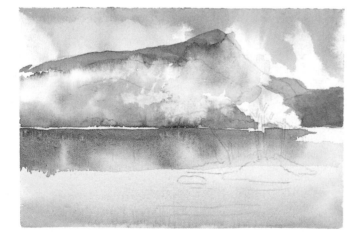

2 When the sky dried, the painting was progressed by wetting selected areas. I laid a band of water, then added the mountain using cobalt mixed with a little cadmium red. When they reached the wet area, these colours diffused to make the mist. I dropped raw sienna and cobalt into the wetted area to make the reflection. The same mix was used above the water's edge to create distant trees.

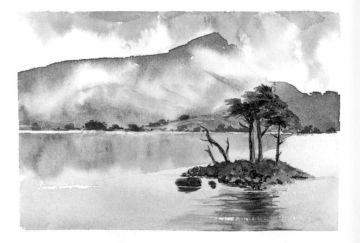

3 To finish, I picked out the distant trees with a stronger mix of cobalt and cadmium red. The island was added using a mix of raw sienna, cadmium red and burnt umber. The foreground trees were viridian with burnt umber and raw sienna for the trunks. I created the reflection and rock with mixes of cobalt and raw sienna, scraping with a knife when dry to make interesting highlights.

The wet-into-wet method may – and often is – used to create a complete picture, but is most useful in conjuction with other techniques. For example, wet-into-wet can be used to capture a moody sky, while the land below is given a more solid look by another watercolour treatment. I wanted the flower arrangement (below) to have the translucence and freedom of wet-into-wet working, but give the flowers a bolder presence. I used a 'cutting out' process to achieve this. The background was painted wet-into-wet, with colours dropped in and allowed to spread. These 'patches' roughly corresponded with the position and colour of different flowers. When this dried, darker colours were added, I built the picture by 'cutting out' flowers from the light background. This is a 'negative painting' technique whereby the original background is brought to the fore and left in relief as a new background is created by adding dark colours. Once I established the overall shape of my composition, the individual flowers were finished in detail. I have left this painting unfinished, so you can see the cutting out method in progress.

TEACHER'S TIP

Let's be honest – wet-into-wet can be a terrifying technique at first. The artist watches in horror as paint takes on a mind of its own, spreading wildly and threatening to engulf the picture. So have a crumpled tissue or piece of kitchen roll handy. If the paint starts to get out of control and diffuse too widely, a few judicious dabs with absorbent paper should stem the tide. And relax – even the most experienced watercolourists use this simple but effective trick when the occasion demands.

Cut it out

The yellow rose was 'built up' from the background wash, using dry yellow ochre with cadmium red for shadow areas. Burnt sienna and burnt umber have been applied to the centre – and at this stage a yellow ground becomes a flower. The delphiniums have been left unfinished to show how the darker 'background' has been applied last to create the flower shapes. The finished red rose has been surrounded with dark tone to enhance contrast and make it really stand out.

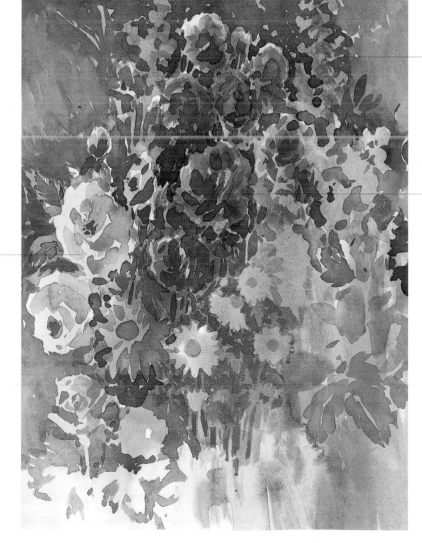

Delphiniums

Red rose

Yellow rose

Dry 'n' drag

Taking the water out of a watercolour can return handsome dividends: try painting directly onto dry paper. This method is particularly useful if you want to paint clear light with strong contrasts. It will also make your brushstrokes more obvious, allowing you to express a little *joie de vivre* in some exuberant brushwork. Just look at the life radiated by my cat Guy, as shown below. Dry paper also works well if you want to add a gentle colour tint to a drawing made in pencil or ink. Minimal amounts of water are used in applying pan paint (tube paints are too strong for this purpose). A succession of 'dry' washes is applied to the dry paper to build a subtle tinted effect that can add a pleasing extra element to the finished drawing. This gives complete control over the use of colour and is best used when you want the drawing itself to remain the focus of attention.

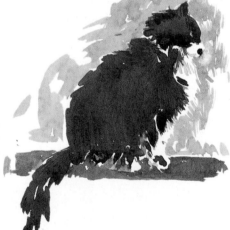

Bold as a brush

Guy was a remarkably well-behaved model for these studies designed to show the strong effect that can be achieved with the 'wet-on-dry' method. I used a medium square-ended sable brush, enabling me to indulge in some free brushwork as I painted in the markings to capture the cat's form. In the large picture, eye detail and whiskers were added with a small round brush. In the smaller studies, backgrounds were added last.

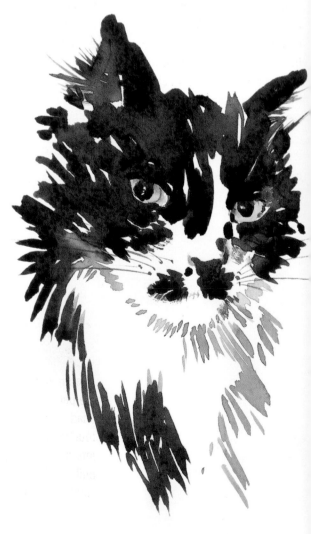

You don't always have to follow convention by 'watering' your brushes, either. Grand effects can be achieved using the 'dry brush' method (also known as 'dragged brushwork') – as I have shown in this step-by-step composition of a dead crab against seashore pebbles. I often use a dry brush in combination with other techniques, painting a wash picture before 'dragging' colour across the surface to give final texture, as here. This is a favourite method for capturing an animal's hair or fur. The paint used must be fairly strong in tone, with very little water on the brush. I like to use a stiff oil-painter's hoghair brush when employing this method. Excess water is removed by pressing a tissue to the heel of the brush (nearest the ferrule end). The bristles should be splayed apart by pinching them, and held in this position as the brush is dragged across the paper. Don't attempt any detail work – the whole point of using dragged brushwork is to achieve a loose but bold final texture.

 Rose madder

 Winsor blue

 Azo yellow

 Primary blue

 Burnt umber

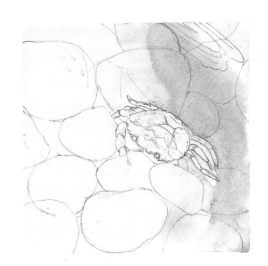

1 With a soft pencil, I drew the pebbles and dead crab, respectfully coating the corpse with masking fluid. This was allowed to dry before the paper was wetted. I laid a yellow wash over the pebble area and added a blue wash to the right. These colours were allowed to blend and merge at the edges. I had a cup of tea from the flask and explored nearby rock pools while this stage was drying.

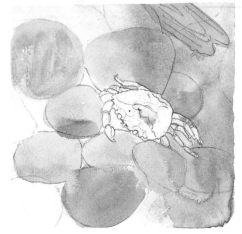

2 Back at the easel, I wetted the paper all over, dropping rose madder 'wet-into-wet' and allowing it to spread indiscriminately. When dry, I worked on shadow and darker areas in burnt umber and primary blue. The same colours were dotted onto wet pebbles to create surface scarring. I then did a little work on the driftwood with yellow and rose madder, dropped in while wet.

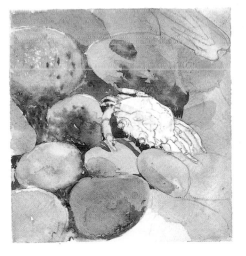

3 The main mix (burnt umber and primary blue) was used for the dry brush colour. I used my old medium-sized hoghair brush and dragged it across the pebbles, concentrating on enhancing shadowed areas, using the lightest of touches with the driftwood. This is the intermediate stage – I continued until I had built up the strong forms and bold contrast I wanted in the finished picture.

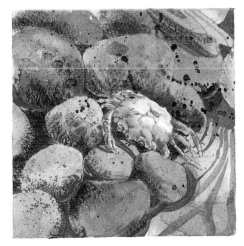

4 I added a flourish of spatter effect, using the umber-and-blue mix on an old toothbrush that I flicked with the handle of my hoghair. Masking fluid was removed from the crab and the bleached shell colour created with mixes of rose madder and yellow. Winsor blue was used to strengthen shadows. Finally, a thin yellow was washed over the whole picture to give a warming feel of the afternoon sun.

Glazed over

The oil painters' union may be outraged, but imitation is the sincerest form of flattery. We watercolourists have boldly borrowed the time-honoured technique of glazing from oil painting, where it has been in use for centuries, and happily use it to produce watercolours that possess wonderful depth and luminosity. This method exploits the main characteristic of watercolour paints – their transparency – to great effect. Sometimes known as 'wet-on-dry', glazing creates a finish that is simply not achievable by merely mixing washes. In glazing, paint is applied in dilute layers, each new layer being applied only after the one below has been allowed to dry. Because these glazed layers are transparent, light travels

through them and is reflected back off the white paper, which causes the picture to glow with a rich subtlety. For best results, I prefer to use those colours with transparent pigments: Winsor or azo yellow, aureolin, gamboge, rose madder or alizarin crimson, Winsor blue or primary blue, viridian green, and cobalt blue. Don't rush – after each layer of glaze is applied, it must be allowed to dry completely. If not, layers mingle and become muddy. Basic rules are that no more than three layers of glaze should be used in any painting, and the lighter coloured glazes should be applied first. But don't be afraid to bend (or even break) those rules – experiment with the myriad effects that can be achieved with extra layers, different colours and application

sequences. Glazing has one other benefit. By painting wet-on-dry, you can capture subjects with precise shapes and hard edges, without suffering the bleed that occurs using wet-into-wet. Rinse brushes and change the water frequently to avoid contamination of new layers.

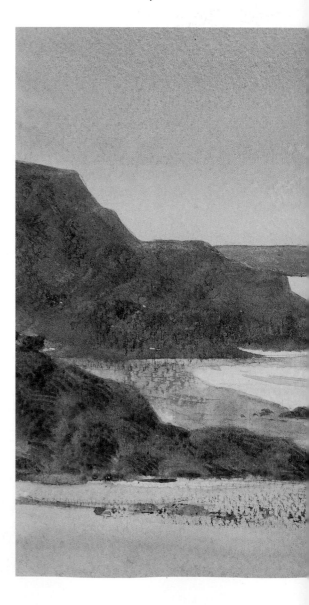

Raw sienna

Rose madder

Cobalt

Beachcombing

Just the three colours shown on the left were used for this atmospheric beach scene and – with the exception of one man and his dog, who were added after the last layer had dried – I built up the entire composition with glazes. This picture shows how effectively this technique captures an almost tangible sense of the prevailing lighting conditions, in this case approaching night as the sun sets over sea and shore.

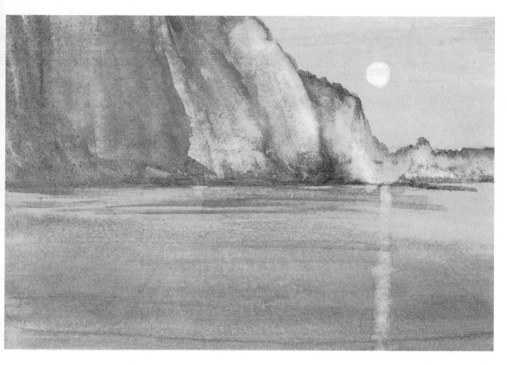

Cobalt **Raw sienna** **Azo yellow**

Moon magic

Here's what you can achieve when you do experiment. This method of glazing is known as 'wiping out' and produces a wonderfully evocative result. A ground of white paint was laid over the paper. When dry, I worked on glazed layers of the three colours shown above, in that order. Highlights (the moon, illuminated headland and reflection) were created by loosening paint with a wet brush and wiping out the lights with a tissue.

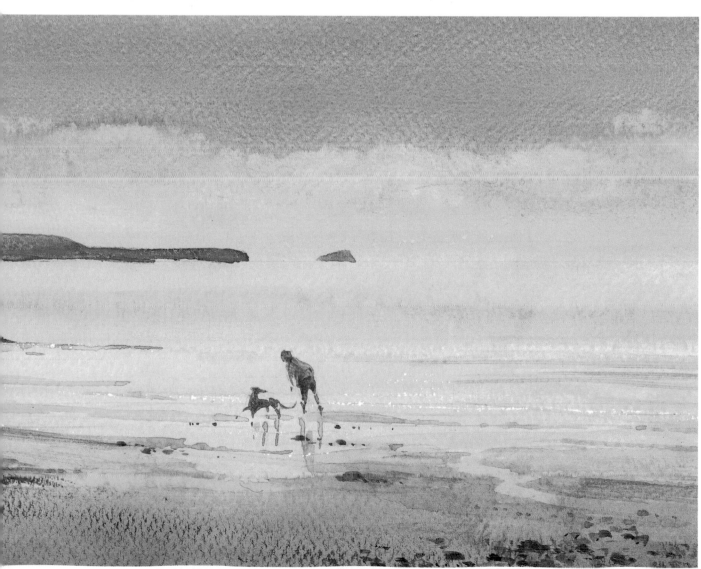

Added value

Winter salt

Despite my advice that additives are best used sparingly, this snowy forest got the full treatment, with salt liberally applied to each wash. It took a while for the washes to dry, but the wait was justified. Close up, the surface almost sparkles, and as you take a step back the salt speckles merge together into a descriptive frosty texture.

Some people like their whisky with no more than a drop of water, while others prefer more exotic mixers. And so it is with watercolour painting. Without losing the transparency and vitality that characterize the true watercolour, there are various techniques involving the use of additives that can add impact and intensity to the finished picture – by creating more surface interest, increasing contrast or helping you to make paint behave in unusual ways. Here are two of my favourites. Adding a little liquid soap (or even washing-up liquid) to watercolour makes brushmarks stand out and encourages expressiveness with the brush. For best results, use more soap than water and work on a smooth paper. Salt can be used to produce an unusual textured finish. Lay a wash of colour and drop salt on before it dries. Wet colour will be drawn into the salt. Allow to dry completely before brushing off the excess salt, which will leave behind a 'speckled' surface texture. Salt works especially well with darker washes and makes a tremendous contribution to any picture that features ice or snow.

TEACHER'S TIP

Once, felt-tip pens and 'art' met only at the point where a young child was given a colouring book and a pack of colourful pens, but it is now possible to obtain light-fast 'studio' felt-tips used by graphic designers for creating visual treatments. You could 'paint' a complete picture with these, but their real value lies in enhancing a watercolour, or even (in touch-up mode) rescuing one. Used over dry paint, they enhance colour. I find the more subtle colours are most useful.

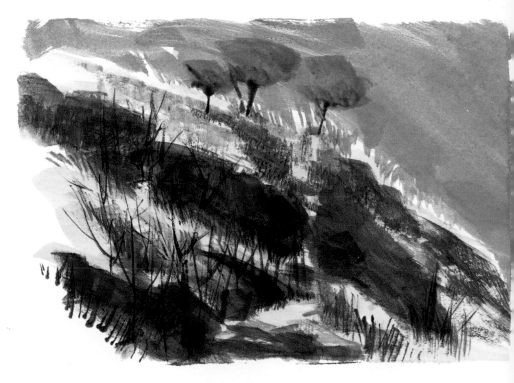

Soap and water

The sheer impact made by this steep, rocky hillside was achieved by using liquid soap to create the density of the rocks and silhouetted trees. Additives can be at their most effective when applied sparingly to create a striking feature within the general composition.

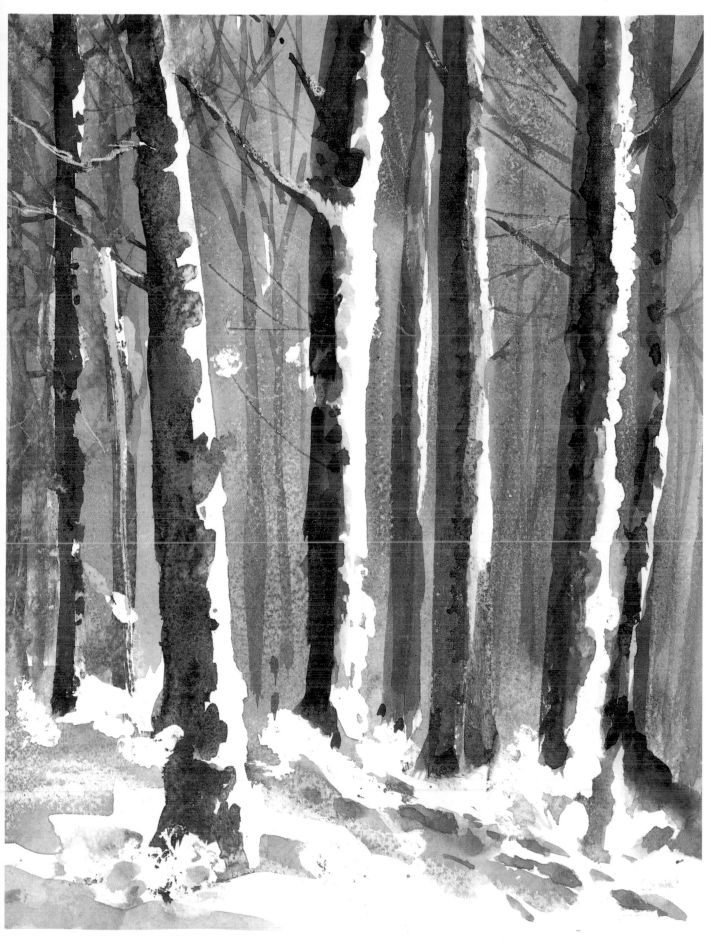

Mixing the media

In addition to 'mixing it' with selected items from the kitchen cupboard, watercolour can be combined very successfully with different artistic media. On the following pages, some of the more significant 'mixed media' applications are considered. Judiciously used, they could add dynamic interest to your work. Even so, you should not become over-reliant on mixed media. It's easy to get carried away by striking effects that can be achieved with some of these 'mixes', but I feel the committed watercolourist should use them to enhance rather than replace the natural appeal of classic watercolours – adding intensity and vitality without swamping their integrity and character.

Pastels and pastel pencils

The beauty of watercolour paints lies in their transparency, which allows light to pass through and reflect back for that luminous look. But sometimes a denser, more solid look can suit the mood you want to create. Here, I rubbed pastels into the sky to convey colours not easily obtained in watercolour alone, and also the 'heavy' texture of a stormy sky. Foreground grasses were strengthened with pastel pencils, while the river and land beyond were left as untouched watercolour.

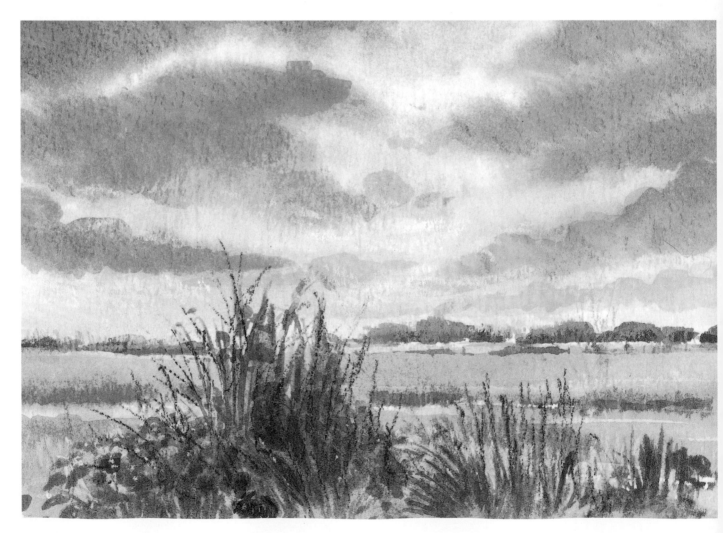

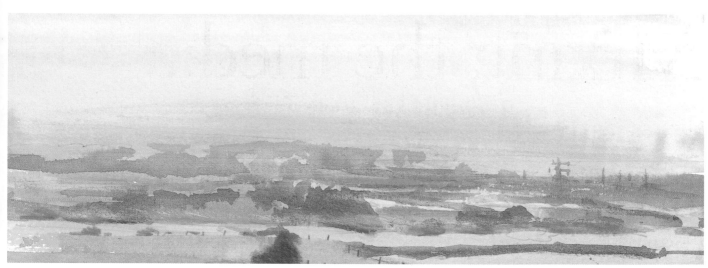

Coloured pencils

I always carry coloured pencils on painting trips. They have a similar effect to pastels – creating opacity that allows me to enhance a watercolour by strengthening selected areas or adding detailed fine-line definition. They can also rescue a tone that has become too strong – a gentle rub will 'flatten' it by reducing transparency. And, unlike pastel, pencils can be erased. I make most use of tertiary colours (greys, green and buffs), plus white to soften tones and add misty effects or distant smoke. This ethereal watercolour landscape benefited from the touch of solidity brought by coloured pencil work to the trees and hedges.

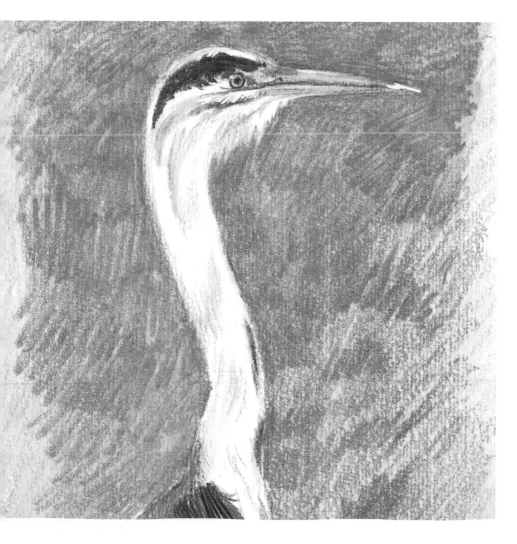

Watercolour pencils

These are water-soluble coloured pencils that can be mixed together in washes when wet. Although this mimics true watercolour painting, pencils work better on a smaller scale, as they cannot produce large washes of colour. I find them useful for detailed work, especially botanical or animal illustration. I drew the heron with watercolour pencils, then added a light background wash using conventional watercolour technique. After the wash dried, I returned to the pencils, working up the strong background texture that makes the bird stand out.

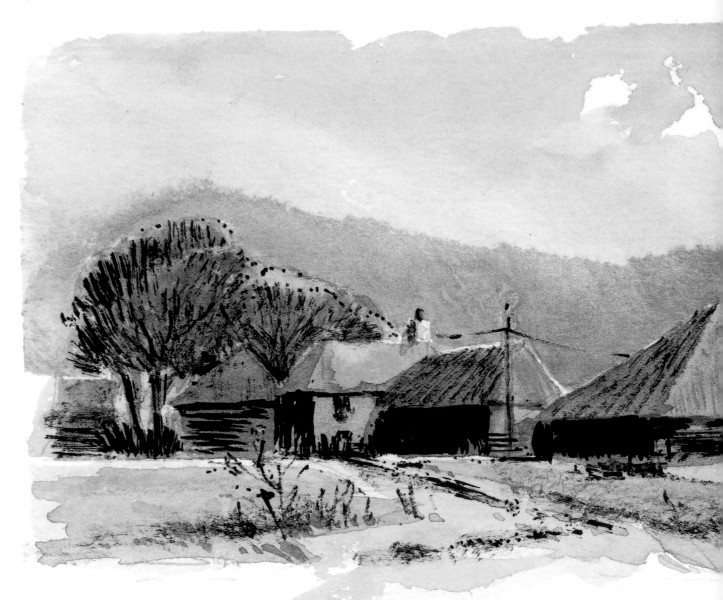

Brushed ink

For maximum impact, try using a brush and ink to strengthen your watercolours. Painting shadows with black ink not only gives them a tremendous presence in their own right, but also generates strong contrast that makes the colours painted in watercolour seem more vibrant – as this picture of old barns illustrates. This is because when the eye sees dark shadow in a painting it assumes the light is also bright . . . and bright light brings out the best in colour. When using the brushed ink technique, you can afford to saturate your colours slightly, in order to take full advantage of this phenomenon. On a cautionary note, ink ravages brush hairs, so use an old brush if possible and always wash it immediately before the ink settles and becomes impossible to remove.

TEACHER'S TIP

Quill feathers make good tools for line and other detailed work. But – believe it or not – there tends to be a bias towards right- or left-handed quills, depending on which of the bird's wings they originated from. I spent years wondering why I could not hold a quill properly until I realised this weird fact and made sure I had the 'right' quill. Problem solved!

TEACHER'S TIP

Here's a useful suggestion for artists who always carry a sketchpad, even when they're not burdened with full painting equipment. I'm always spotting something that is much too good to leave unrecorded. Try laying down separate squares with watercolour pencils at the back of the book, carry a tiny bottle of water and small brush . . . and use it to wet the squares. And there you have instant watercolour to enhance that 'must have' drawing when the moment comes!

Line and wash

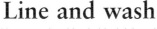

never without my sketchbook, black ink and assortment of pens, twigs and brushes with ch to put that ink on paper. Line and wash is a mixed medium where (for once) the tercolour element (though making a delicate nd valuable contribution to the end result) is servient to a stronger master — bold images black ink. I use waterproof Indian ink (acrylic ik is also suitable) which when dry, does not bleed if watercolour washes are applied over e top. Line and wash pictures are essentially ink (or pencil) drawings that are tinted with watercolour after the drawing is completed. I se line and wash a lot — both to create lively riginal scenes like these tourists in Florence, for studies I intend to use later as reference for fully worked watercolours.

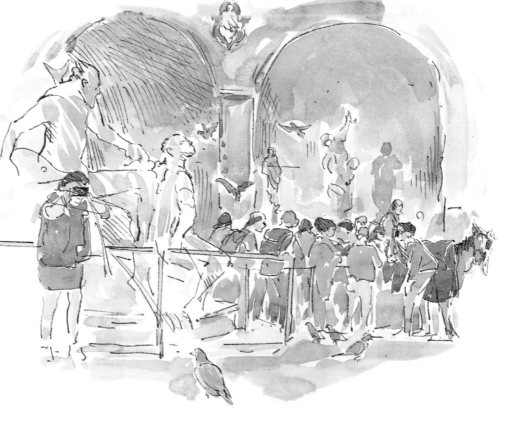

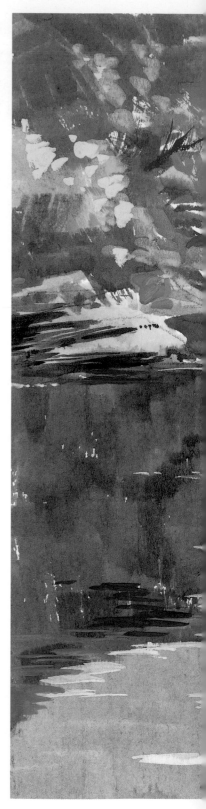

Aquarelle (neocolour)

Think sticks of watercolour bound with soluble wax and you're thinking aquarelle. They have properties very similar to those of watercolour pencils and are used in the same way – to provide a denser texture and tone effects that transparent watercolours cannot achieve alone, but without the opaque 'flattening' effect of added pastels. The wax element gives a fantastic surface texture – see how powerful the sea-and-skyscape looks after aquarelle has been applied on top of watercolour. As with watercolour pencils, it is difficult to obtain enough colour to make up a large amount of wash from aquarelle.

TEACHER'S TIP

When painting out of doors in strong sunlight, it is wise to seek out a shaded spot to set up your easel. This is not just self-preservation, though that should not be forgotten (I always wear a wide-brimmed hat as protection from the sun). Your picture can suffer, too, because direct sunlight 'bouncing' back off white paper creates a glare that both disorientates your eyes and prevents them properly seeing what's going on the paper.

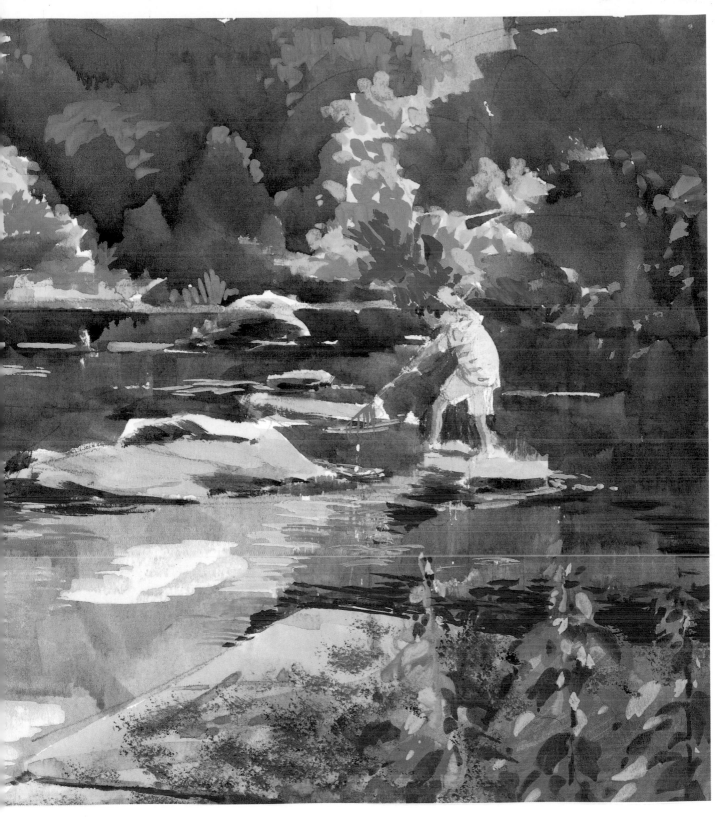

Gouache

This charming river scene is a watercolour – yet it is immediately apparent that the picture lacks the clear, translucent quality that characterizes watercolour painting. Indeed, there are echoes of an oil painting here, in the flat colours and 'layered' surface texture. This is because I used gouache, an opaque form of watercolour. Opacity goes against everything that is sacred about watercolouring, but it can have its uses. Discreetly applied, gouache is ideal for creating or rescuing highlights by adding body and filling in weak areas. It may also be used, as here, for creating a watercolour finish unlike any other. My method of working was from dark to light, using white to lighten colour. Gouache works extremely well on coloured paper.

Sgraffito

And now for something completely different – not a drop of watercolour to be seen here. I have put these fish in because I love working in *sgraffito*, an unusual technique that can produce quite extraordinary images. This Italian word literally means 'scratch out', and originally described a method for creating decorative or figurative work on plaster. Nowadays, oil pastels or wax crayons are used to apply base colours to stretched drawing paper. The whole area is then covered in Indian ink mixed with a little liquid soap (see page 26). When dry, you create your chosen image by scratching off the surface with a nail or blunt knife, as though working on scraperboard. The result of imaginative *sgraffito* work can be very impressive.

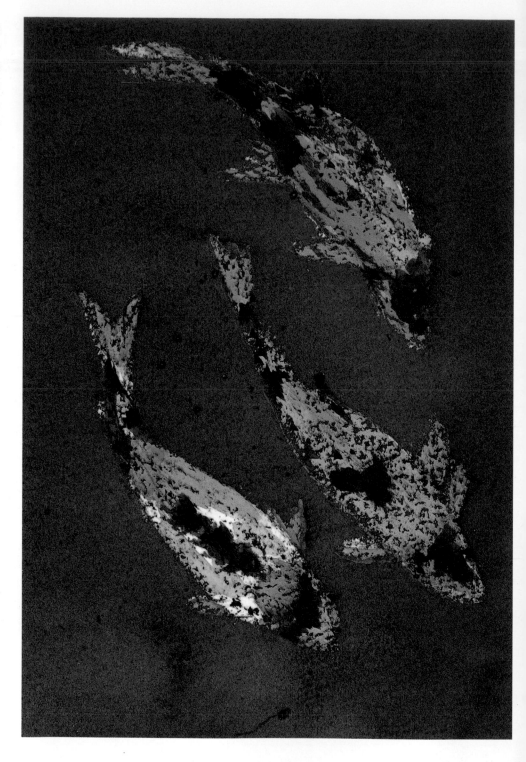

Collage

Last but not least, we come to one of my absolute favourite mixed media methods – tissue collage, as represented by these glowing anemones. To create the transparent look, underpainting is needed. I usually paint a special watercolour, enriched with coloured inks. Alternatively, I recycle a finished painting that has disappointed me. Tissue is torn into small (but not tiny) pieces and stuck to the surface of the dry painting with any paper glue. Make sure there are no gaps between scraps, which may even overlap slightly. When complete, apply strong colour – inks, watercolours or both. The tissue will stain and wrinkle, creating a batik effect. Collage can have an immensely rich and opulent appearance when dry, especially when glazed with varnish.

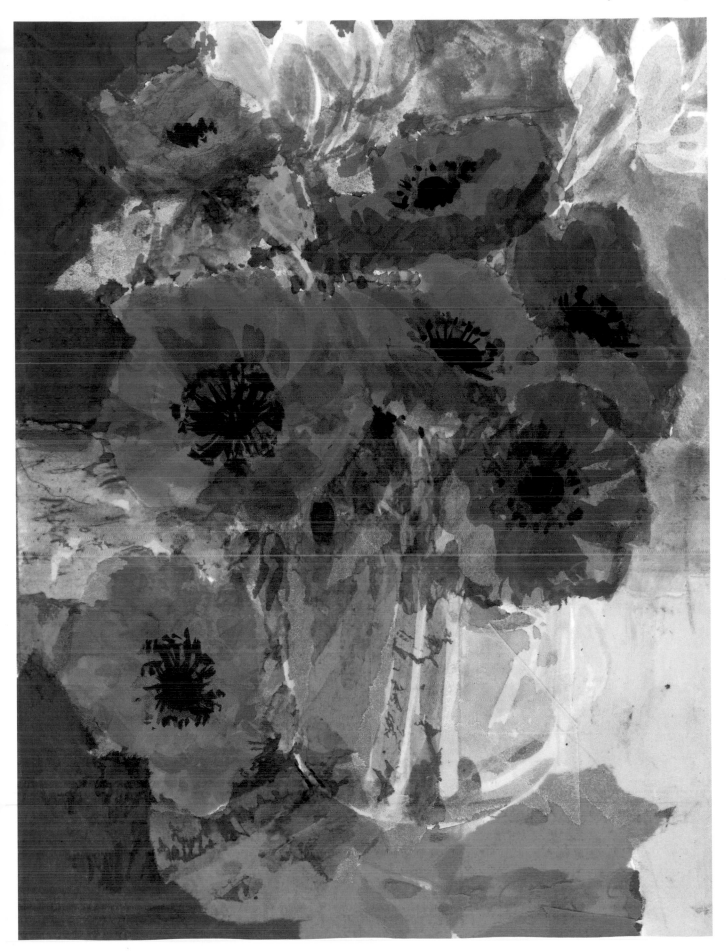

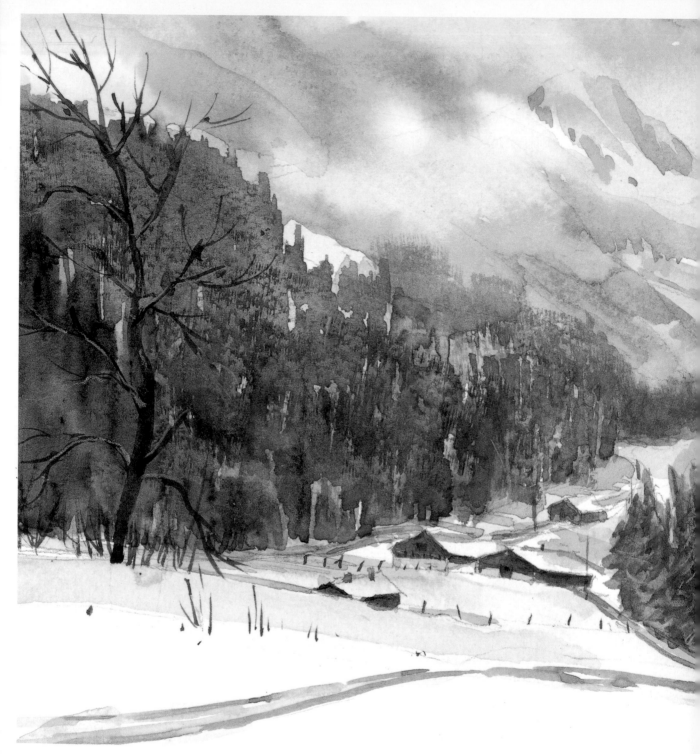

Alpine adventure

There was a danger that this Alpine landscape could end up looking more like a picture postcard than the atmospheric watercolour I wanted to paint. So I concentrated on what attracted me most. The whole scene was breathtaking, but I was most interested in distant sunlight playing on meadows below the snowline, on the lower slopes of a mountain shrouded in mist. By leaving the foreground unpainted, I suggested a snowy hillside without distracting the eye with a mass of sparkling snow and led the viewer into the picture via the rudimentary track. Snow-covered houses were not allowed to become intrusive, and I used the 'funnel' of dark trees to force the eye down the valley to my focal point. The trick of this composition is reversal. The strongly defined and painted foreground elements set the context, but all roads lead to the real star of the show – that subtle, delicately painted background.

Dynamic composition

We have looked at techniques that – well executed and intelligently deployed – can make a watercolour stand out. But the best technique in the world can never rescue a picture if the composition creaks. Should you get it wrong the painting will seem flat and empty. But if you get it right, imaginative composition can 'make' a picture by creating the frisson factor that seizes the eye and demands attention – thus making an invaluable contribution to the continuing quest for more dynamic work.

Floating mountain

This small wash was dashed off quickly, but was designed to draw the eye. I offset the focal point – that thrusting peak – against the wide sky, and left the mountain apparently 'hanging in the air'. The composition therefore consists of two simple but unexpected visual surprises that are designed to catch and hold the viewer's gaze.

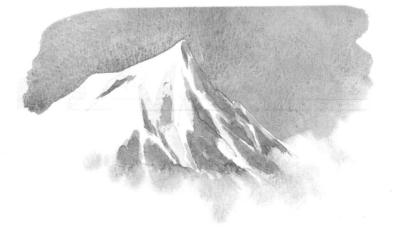

Adjusting reality

TEACHER'S TIP

Who dares wins – or loses! If you attempt daring compositions that break all the rules, failures will occur with depressing regularity. But persevere – the occasional success will be spectacular.

While I explained the thinking behind the Alpine painting that opened this chapter, I neglected to ask an intriguing question. Was I lucky enough to happen upon a perfect composition and have the artistic eye to see it, or did I 'bend' the landscape to suit the painting I wanted to paint? In a sense the answer doesn't really matter, because the camera has long freed artists from the need to paint accurate descriptive pictures of record. Now, we are free to concentrate on what we find interesting and visually exciting. Successful composition does not depend on portraying physical reality, but on your ability to create work that makes people stop and look at what you have *chosen* to paint. As confidence grows, you will learn to trust your instinct. This may mean sometimes composing pictures that bend the visual facts to advantage. In this context, the only reality is what appears in the pictures you paint.

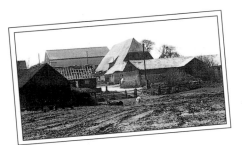

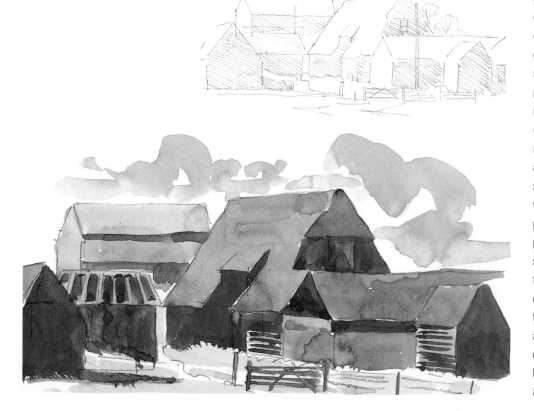

Barnstorming

In order to achieve consistently good compositions, the artist does need an instinctive eye for interesting possibilities, but must always be prepared to give real life a helping hand. Indeed, that's a key compositional skill. To illustrate the point, I decided to turn the black-and-white photo of barns (far left) into the finished picture on the right, showing the two intermediate stages. Although providing a subject, the photo contains no colour, allowing free interpretation. First I made a tonal drawing (above left), to show the overall shape and mass of the buildings. Such a drawing is always helpful before tackling a complex subject, as it allows you to play around with the composition and try various possibilities before committing serious paint to paper. I then made the colour sketch (below left) to help me fine-tune the composition. After studying it, I decided the intrusive central cowshed had to go, and that I would set the buildings against a stormy sky for maximum contrast and effect. Judge for yourself how well a grainy photo was turned into an atmospheric watercolour.

Vanishing act

The finished painting has dark clouds gathering as the barns catch sunlight in the last minutes before the storm breaks. I used glazes for roofs and sky, with a little coloured pencil added to roofs to heighten texture and contrast with the sky. But I 'lost' a couple of features from the colour sketch, to open up the composition.

First you saw it, now you don't. For compositional reasons, I wanted the pale track to disappear behind the dark barn to the left, so the building standing here has vanished.

No sky texture was visible in the photograph, so my sketch had a nominal squiggle of colour. But this stormy sky was an essential element of the finished composition.

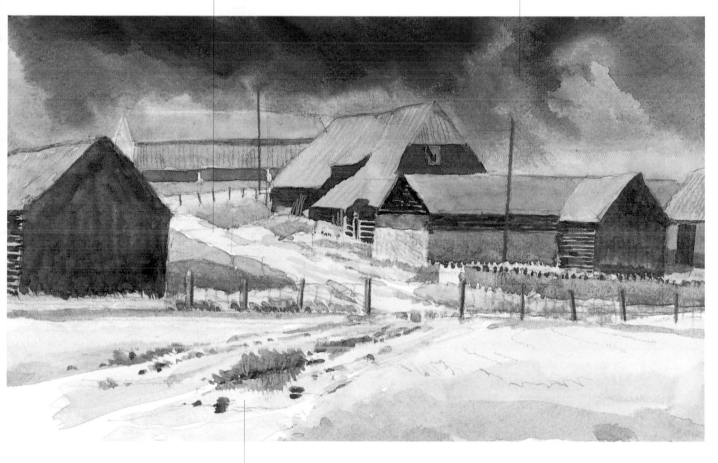

Six into dozens

Below is the limited palette I used for this exercise – it takes time and practice to learn how few colours are needed to paint a dynamic composition that has a tremendous variety of colour and shade.

The colour sketch concentrated on the buildings, ending at the gate. In the finished painting, I interpreted the rough foreground from the photograph creatively, removed the gate and added a track (complete with this interesting puddle) that leads the eye into the heart of the composition.

Raw sienna

Rose madder

Cobalt blue

Primary blue

Azo yellow

Burnt umber

Picturing shapes

The considered positioning of a subject that interests you within a picture is vital. For example, if you decide that those distant mountains overlooking the lake are a most wonderful shape, 'close in' when composing your picture rather than attempting the entire panorama. If a flock of sheep in a snowbound field makes an attractive prospect, ensure they become the focus of attention, instead of merely setting out to paint 'snowy landscape with sheep'. Beyond the general principle that good composition always involves addressing the subject in a way that best presents the visual elements that attracted you in the first place, the significant contribution that picture shape can make is often overlooked. My students usually dash to get started on a subject that excites them, often bringing flair and imagination to the composition. But I sometimes have to remind them that the physical shape they choose can contribute to the success of the piece. It is always worth considering if there might be a particular (perhaps unusual) shape that would enhance or complement the final composition.

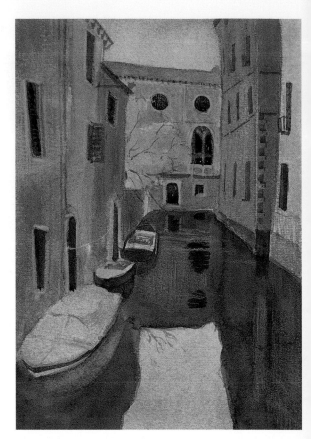

Thinking tall

This is the classic upright 'portrait' shape, so named because it is ideal for painting portraits of upstanding people (sometimes also called 'poster' shape). You can use it for pictures like this Venetian canal scene, where the composition was 'made' by the shape and would not have worked at all in a horizontal format.

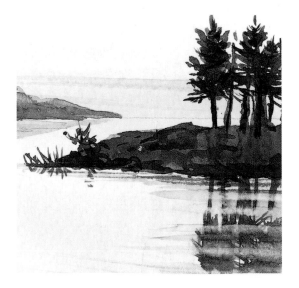

Square bashing

Because of its regular shape, the square is not considered the ideal choice for picture composition. But breaking the rules occasionally is no bad thing and can certainly give the viewer pause for thought. I feel this island and offset reflected trees, 'balanced' by the spit in the background, makes a conventional lake view more interesting and unusual.

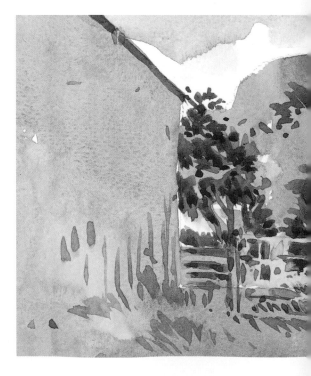

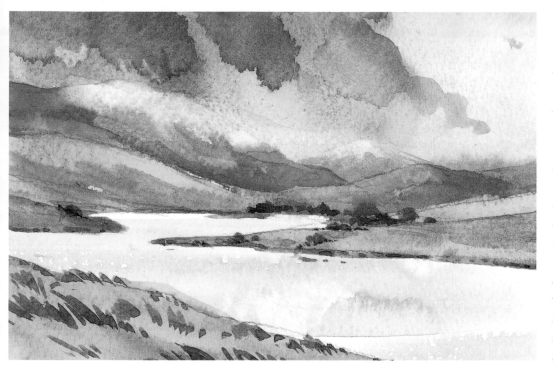

Landscaped

This is the horizontal 'landscape' shape – so obviously well-suited to this picture featuring a river and shrouded mountain beneath a gathering storm. It is ideal for this classic composition, where the river leads the eye straight to the dramatic sky. Just because rules can sometimes be broken to good effect, it doesn't mean they should regularly be flouted. On the contrary, if you over-exploit 'shock tactics' of unconventional picture shapes or techniques, these show-stoppers will lose their ability to lift your work.

The panoramic view

Technically, this view of trees and fences is a landscape picture, in both shape and subject. But by extending the horizontal scale I have created something a little different, which perfectly illustrates the way in which choice of shape can play a key role in determining composition. The strength of this picture depends on the fact that – thanks to its elongated shape – a tremendous sense of sweeping scale is created, as the eye moves from the barn in left foreground to the sunlit tree, then on down the line of trees to the distant hills. And if it makes for a striking landscape, just imagine what it might do for a still life.

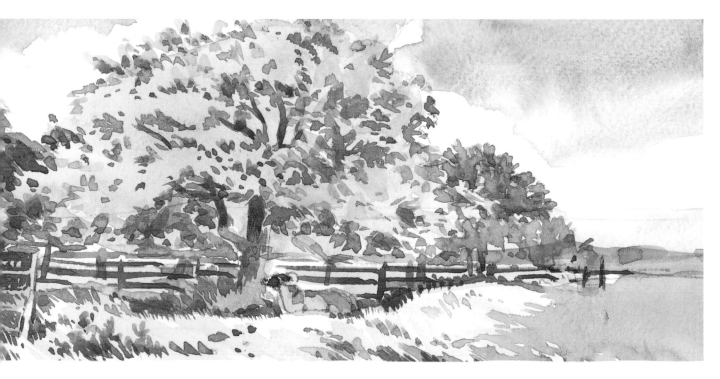

Placing your subject

We've all heard of golden rules, and the one that governs the successful placement of the main subject within a picture is called the 'golden section' or 'golden mean'. It was developed by philosopher-mathematicians in Ancient Greece and I won't bend your mind (or mine!) with the complex equation. All we need to know is that their theory allows us to calculate the point at which salient objects can be placed within a picture in order to seem harmoniously arranged within the whole, by applying a standard ratio of 8:13. Actually, there's a simple practical method of working it out. Measure the short side of a landscape picture shape, apply that measurement to the longer side (working in from either left or right edge) and then draw a vertical line. Anything placed on that line will work well as a focal point for the composition. The same is true for a portrait shape. This relationship often occurs in nature – for example in the arrangment of spirals inside seashells and formation of seeds in sunflower heads. The human eye finds this pattern particularly pleasing.

It has been extensively used by artists in the past and I find that even beginners tend to use the method instinctively.

TEACHER'S TIP

To help with composition, I carry an 'instant viewfinder' – a postcard-sized piece of stiff paper or card with a small rectangle cut out is ideal and easy to make (I'm always losing them!). I keep mine tucked in my sketchbook and find it invaluable in 'sizing up' the various possibilities when planning a picture. Use a viewfinder to experiment. By holding it at varying distances from the eye, you can preview alternative treatments of a subject, often coming up with an imaginative composition that wasn't the first one you considered first.

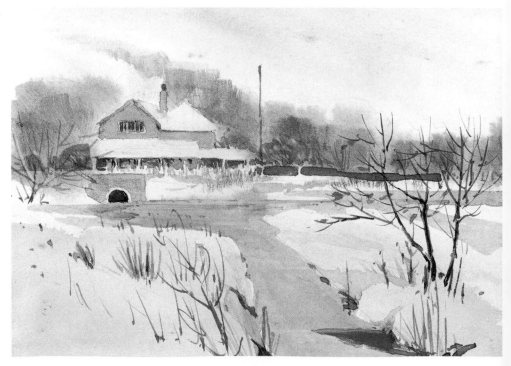

On golden pond

In addition to the well-used but ever-effective device of channeling the viewer's eye into the picture (quite literally in this case, as it follows the frozen stream), this winter scene benefits from application of the 'golden section'. I positioned the house above the point where – measuring along the base from the right edge – the length of the picture's shorter side falls.

The right angle

Placing subjects off-centre somehow makes them more compelling to look at – note how these primulas stand out. I've placed a napkin to the left, adding interest and filling otherwise empty space without competing with the main focus of the picture. And it is always worth varying the angle from which you view – in this case, choosing to 'look down' gave me more of the rich flowers to paint.

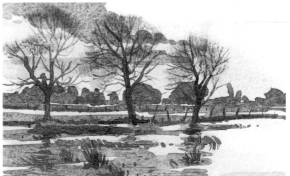

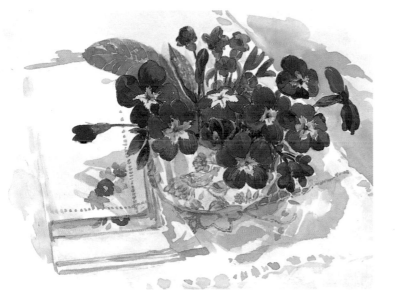

Odd numbers

The eye's natural preference appears to be for odd numbers, so turn that to compositional advantage – three trees instead of four, as in this study of a flooded field, seven sheep instead of eight, five flowers not six . . . it seems to work.

Thirds rule, okay?

Talking of threes, any composition based on a triangular shape is likely to be successful. And the 'intersection of thirds' is another useful compositional device. Placing the sky either one third or two thirds of the way up works well. And dividing the picture into thirds is a useful way of deciding where key elements should go, as with this Dutch canalside scene. The lifting bridge sits on one line and ends at the junction of two, while the street lamp is positioned on an upright line.

Horizons and eye level

In landscapes, the horizon is a critical parameter. The point at which the horizon line is placed will have a significant effect on the painting's impact, so this becomes a vital compositional decision. If you choose to use the 'rule of thirds' you have to decide between placing the horizon one third of the way up a picture, or one third of the

way down. Your choice will determine the mood and feel of the finished work, as the two alternative versions of the same landscape reproduced below confirm. The top one is the sort of watercolour painted before the invention of the camera to record accurate 'copies' of landscapes for posterity. By way of contrast, the lower picture is

much more in line with the modern watercolourist's interest in 'atmospherics'. Eye level – the angle from which a particular scene or subject is painted – is another factor that can alter a picture's character. It's worth taking a little time to look for – and hopefully find – unusual viewpoints that can bring fresh impetus to your painting.

The high road

With the horizon a third of the way up this picture, the emphasis is on the bottom two-thirds, occupied by the land. The centre of interest is therefore the slumbering landscape bathed in gentle sunlight – a typical 'topographical' composition.

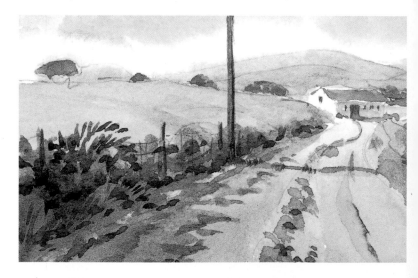

The low road

Here the emphasis is reversed, with the land taking second place to the 'big' sky that occupies the top two-thirds of the picture. The mood is therefore set by the dramatic sky. The landscape is still lit by glancing sunlight, but seems altogether less serene.

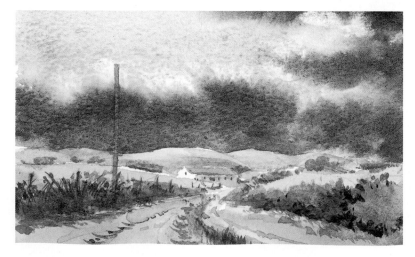

TEACHER'S TIP

As an exercise in composition, lay out some recent paintings and take four sheets of card. Use these to 'reframe' the pictures, cropping in several ways – changing the shape and concentrating on different parts of each picture. You will see that scenes you painted one way could so easily have made many different and interesting compositions.

Mouse's-eye view

This stone portico might have looked very ordinary if painted 'front on', but by opting for a close-up ground-level perspective I have created an unusual image that challenges the eye and demands a second look. By slightly exaggerating the amount by which the perspective narrows, I gave the building a massive and imposing presence.

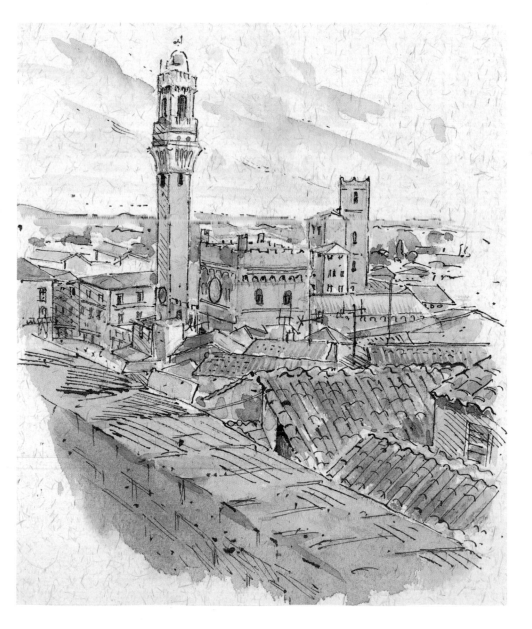

Bird's-eye view

It is always worth looking for a viewpoint that allows you to take a 'fresh' look at a subject. After painting several bustling scenes in Sienna's narrow streets, I found a vantage point atop a church tower that offered a charming view of ancient clay-tiled roofs that glowed with the subtle terracotta hues so characteristic of Italy. Roofscapes often make wonderful and unusual compositions – providing, of course, that you have a head for heights.

Playing with scale

It's mad, bad and dangerous – but nothing has the potential to make a more dynamic impact on your work than playing with scale. The very discernment that causes the critical human eye to fasten on compositional flaws like badly placed shadows or incorrect perspective – and mark down the offending painting accordingly – can be turned to advantage. By creating pictures where scale is manipulated to the extent where it is obviously 'wrong', you compel immediate attention. Once you've grabbed the viewer, potential criticism can turn to surprise and delight if your manipulation of scale is so bizarre that it is clearly not an error, but an intriguingly deliberate composition. Success often depends on comparisons or deliberate distortions that are ludicrous. It isn't easy to carry this off, but when they work out these these 'surreal' pictures can have a quite extraordinary impact. And this daring approach allows you to introduces another ingredient that can make your work stand out, which isn't usually available to the watercolourist but sits perfectly alongside surrealism – humour. Don't underestimate the positive power of humour. Smiling makes people feel good – and if it's your picture that makes them smile, it's your picture they'll feel good about.

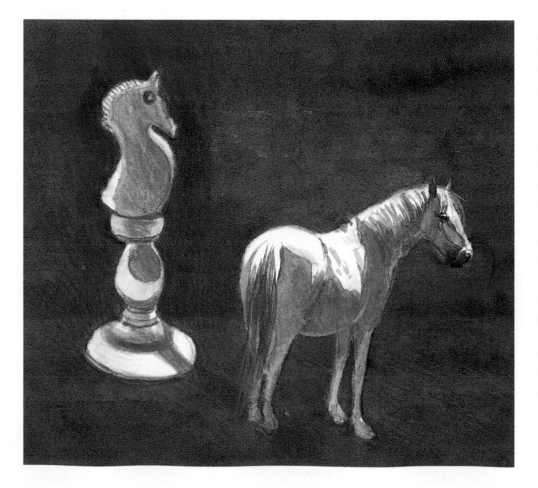

Knight rider

This is a typical surrealistic composition. When you are thinking about painting a picture like this, you must of course come up with a striking composition – but ideally it should also be thought-provoking or even try to make a point.

Thus, while a Salvador Dali 'melting watch' is fascinating to look at, it hints at the way time inexorably runs away. In this picture, I liked the quirky juxtaposition of the chess knight that is actually a horse with a real horse the size of a chess piece. To make this picture, I painted both objects from life, but the scale of the chess piece was altered to make it appear huge compared with the genuine horse. When 'marrying' two pictures, be careful to ensure that light and shadow are consistent for both objects.

Slice of life

There are several worthwhile ploys used to add interest to this apparently simple still life. The first involves unnatural scale. Unfortunately, the constraints of a book page prevent you from getting the full impact – but this is a large painting that shows the humble tomato at least ten times larger than it could ever be in real life. The second device is the use of an unusual viewpoint. The eye instantly identifies this tomato as a familiar three-dimensional object, yet this composition renders the object as flat, causing the viewer to do a 'double take'. The last trick involved choosing a square shape for a patently round subject. The result of all that 'trickery'? An unusual and eye-catching painting that grabs attention.

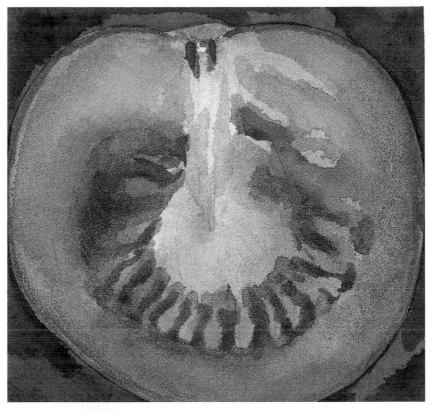

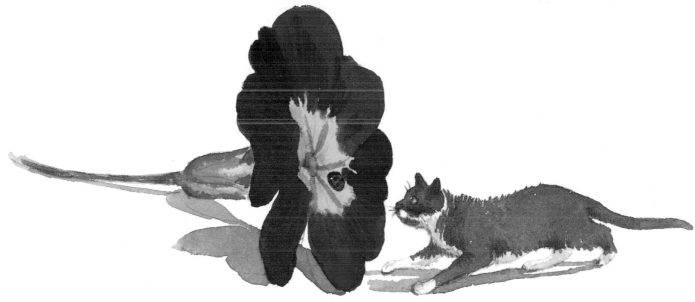

TEACHER'S TIP

In Western culture, the eye habitually reads from left to right, and we instinctively assess a picture in the same way. That doesn't mean you should always place figures or focal points to the left, but if the composition reflects that preference it has a head start in the 'approval rating' stakes. Try it and see!

Flower power

Playing with scale can certainly add a surreal quality to your work, as here with 'moggy meets megaflower'. And I keep imagining the expression on the cat's face when the giant ladybird bursts forth from the flower! It is difficult to inject humour into watercolours without descending into caricature, though it is sometimes possible to slip (say) a mouse into an unobtrusive corner of a picture to amuse those who notice it. But surreal paintings are an exception.

Breaking free

Who makes the rules? It does help to be aware of (and generally pay some attention to!) those tried and tested principles that govern good composition – but they are really no more than sound guidelines. Follow them, and they will almost guarantee a well-balanced composition – but life (and art!) would be deadly dull if nobody ever got around to breaking them. So you should not underestimate the importance or validity of your instincts. Drawing and painting are communication with lines and paint. You want to 'talk visually' with those who view the work – and the key word is YOU. Ultimately, *you* must have something to say and *you* are the only one who can decide what *you* want to communicate . . . and how *you* can best express it. So don't get rulebound – head straight for what matters to *you* and aim to express 'the message' in your own unique way. The cleverest technique, beautifully applied washes and superb texture are irrelevant if the picture has nothing to say but 'look how pretty I am'. Besides, breaking the rules is fun! Even if some of your escapades end in failure, you'll learn a lot. And you will find that some of your most dynamic pictures are composed by deliberately breaking those rules. Dare to be different!

TEACHER'S TIP

To refresh compositional skills, try drawing out a painting – from life or a sketch – *upside down*. This is an effective way of organising shapes to their best advantage – or perhaps that should read *reorganising*. It's easy to fall into visual clichés, drawing familiar things in the usual way without looking for a better way. Inverting the composition gives new insight, and if you can actually paint in 'upside-down mode' as well as drawing out, you may be pleasantly surprised by the result.

Portraits of a lady

The rules of picture making state that objects should not be placed too close to the bottom of a composition, where they can appear to 'drop out' of the picture. But if the subject makes a strong shape (as in the 'tall lady' portrait to the right) and is balanced by a strong colour at the top, this rule can safely be broken. Likewise, it isn't necessary to use a classic portrait shape for a portrait, as the version below shows.

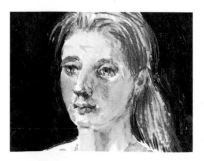

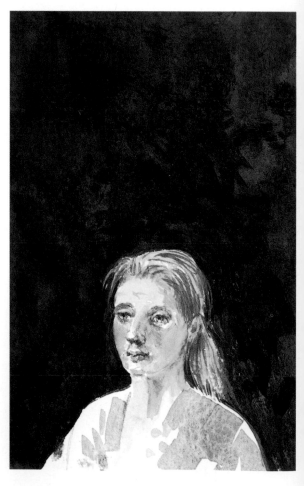

Crooked mile

If you want to make things really exciting (and disturbing), try tilting the angle of the horizon. Here, some old stone steps in the suq have been tilted to emphasise their compositional quality, and also antiquity. But don't stop there – for really bold impact, try skewing the horizon in a seascape or even (if you are feeling bold!) a landscape.

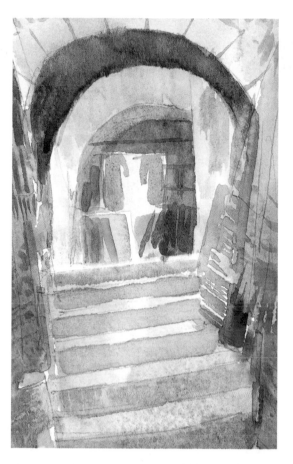

Hustle and bustle

Placing figures near the frame is frowned on – but breaking this rule can generate a dynamic impression, as in this street café by night. As the waiter walks out of the picture, a lively impression of bustle and haste is created. Consider why a rule exists (in this case to create a compact and focused composition) and work out if breaking it might therefore have an unsettling but energizing effect.

TEACHER'S TIP

We all hate politicians who talk (loudly) the whole time to avoid anyone else getting a word in. So why make that mistake in your own work? Painting is like talking. A good conversation should involve communication, changes of cadence, inflections, nuances and pauses to allow response. In painting terms, this means stressing the main subject, leaving quieter areas to emphasize your point. Colour provides those important inflections and cadences.

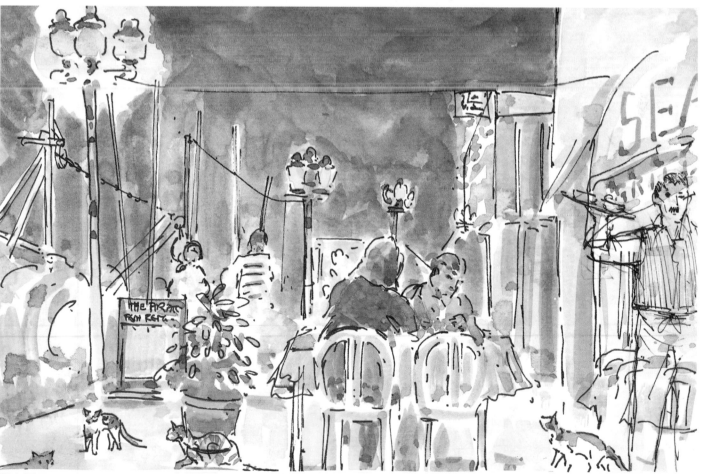

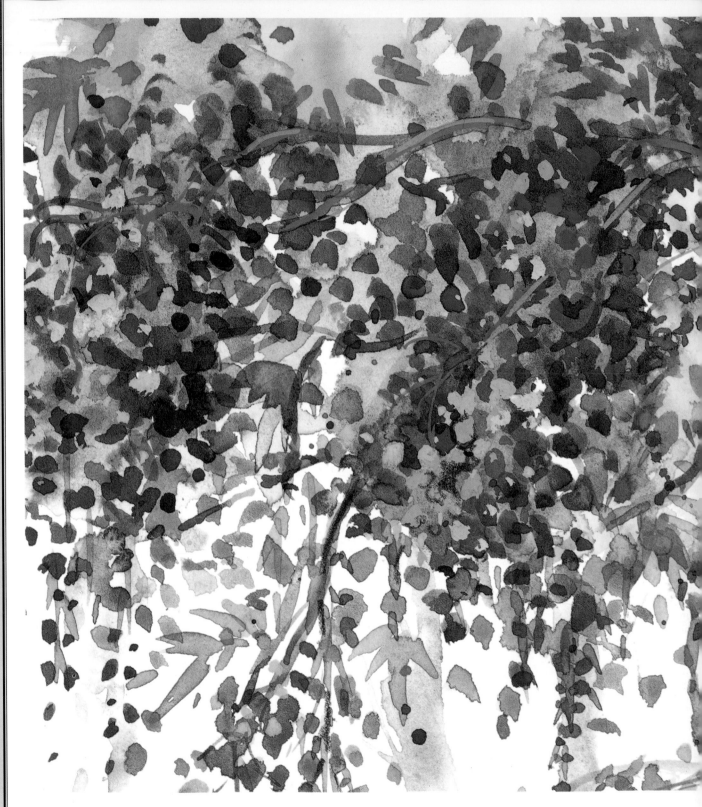

Opulent colour

This picture communicates the extraordinary potential of watercolour paint – and the opulent use of colour the medium encourages. The uninhibited riot of wisteria flowers was painted on a smooth hot-pressed paper to keep the colours crisp and sharp. Mixes of Winsor blue with rose madder and cobalt were used for the flowers. With the exception of a little gouache mixed with the same colours to create lighter branches, and azo yellow to mix green foliage, that was it colourwise – so this energetic composition was achieved by using just four colours.

Dynamic colour

Understanding the varied and delightful applications of the 'colour' element in watercolour isn't easy – indeed, any dedicated watercolour painter will admit that they never reach the top of the learning curve. But that is exactly as it should be, because finding out what can be achieved with colour is at the heart of the watercolourist's art. You can never hope to know it all. But if there is one sure way of improving your work and creating more dynamic pictures, it lies in exploring and exploiting the limitless qualities and capabilities of colour.

Primary colour

This simple still life uses only the primary colours of red, blue and yellow at various strengths to create a bright, strong composition. ...ping your colours clean and mixing them on the paper makes for a vibrant result where colour is allowed to make its own statement.

Clean colours

In theory, any colour can be mixed from the three primary colours – red, blue and yellow. If only using colours were that simple. But we can learn from the printing industry: four-colour printing tries to match colour by mixing black with the three primaries – magenta (red), cyan (blue) and yellow. But this is not possible, which is why custom printing inks are made in thousands of specific colours. As any printer will tell you, the real weakness of the four-colour process is that it causes certain colours to go 'flat' or 'muddy',

because there is no possible combination that matches. The lesson for the watercolourist is this: if you want to achieve clean colour effects, do not over-mix colours in the quest for the perfect shade. To avoid that dreaded muddy finish, never mix more than three colours together, and aim for two. Do not be tempted by that endless selection of colours in the art shop, either – you will do so much better by keeping the colours in your box to a carefully chosen minimum and exploring the wide range of colour effects you can achieve

with that limited palette. Start with the transparent 'saturated' colours shown below, which are sure to deliver brilliance and power to your work. As you learn to control the strength of colour (tone), you will find that these key colours can offer endless fascinating possibilities. Then experiment with a wider range of colours. The joy of watercolour is its freshness and transparency, so never spoil your work by over-mixing or over-painting. Let pure, clean colour work for you.

Clear transparent colours

These are the clearest, most transparent colours. To understand the difference clear colours can make, paint the same subject twice, as I did with these trees. For the tree on the left, I used clear saturated colours – cobalt, azo yellow, viridian green and raw sienna. The tree on the right was painted in light red, cadmium yellow deep, cerulean, French ultramarine and yellow ochre – all unsaturated colours that the manufacturer produces by premixing pigments. Most manufacturers offer useful printed guides that classify their colours by purity, and these are required reading for the student of effective colour use.

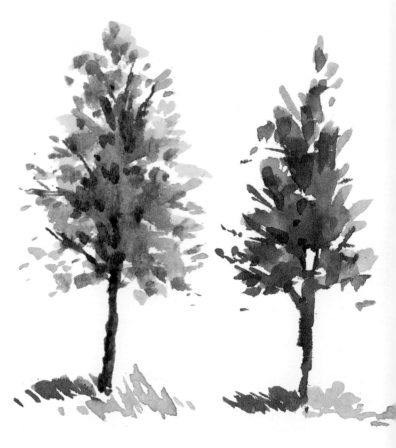

Azo yellow

Cobalt blue

Winsor blue

Viridian green

Alizarin crimson

Raw sienna

Study in green

My intention here was to use pure colour to explore shapes, so there was no drawing and hardly any colour mixing. With the exception of reflective water, this composition consists of patches of clean colour placed next to each other. Tiny gaps give a vibrant appearance, allowing me to achieve a glowing colour effect much brighter than that normally seen in landscape painting.

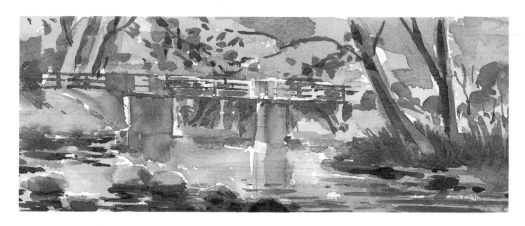

Cobalt with raw sienna dropped in

Cobalt with burnt sienna dropped in

Cerulean with raw umber dropped in

Dropping in

Mixing transparent colours will prevent muddy results – and you can get really exciting and interesting colour effects by dropping one colour into another instead of mixing, as shown here. This technique takes full advantage of the translucent quality of pure watercolour paints. As a general rule, colours mixed on the paper will give a much cleaner and more satisfactory result than those ready-mixed before application.

Bright landscape

To illustrate the wonderfully clean and bright watercolour pictures that can result when you decide to use only transparent colours, I painted this Spanish mountain scene using Winsor blue, cobalt, alizarin, azo yellow, raw sienna and viridian. Had the composition needed some strong, dense shadow areas I would have mixed in more opaque colours. Used in moderation, this would not have detracted from the fresh feel, instead emphasizing the pure overall colour values.

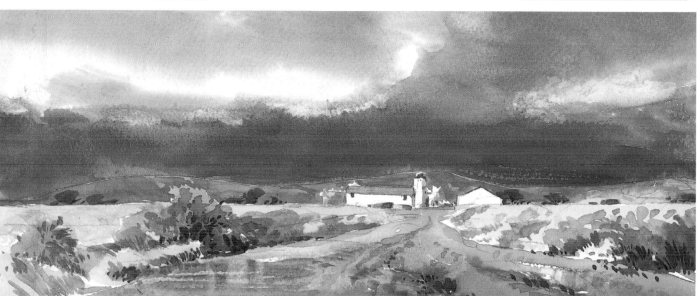

Complementary colours

Alas, there is no magic formula that can guarantee the creation of more dynamic watercolours, but there is one vital ingredient that will definitely add life, energy and movement to your work. By understanding the special characteristics of complementary colours and deploying them well, you will paint more vibrant pictures. The primary colours are red, yellow and blue. A complementary colour is a mix of any two that becomes the complementary of the third. Thus, red mixed with yellow gives orange, which is complementary to blue. Yellow mixed with blue is green, the complementary of red, and so on. But 'complementary' is a somewhat misleading term, as it implies a degree of harmony. Yet complementary colours are actually opposed to each other visually, and this is the factor that makes them 'work' for the watercolourist. When placed side by side, complementaries clash, alerting the eye. They seem to 'vibrate', thus adding movement to the picture. When complementary colours are used at equal strengths they will fight, creating disturbing discord rather than having the desired effect of attracting attention and imparting life. You will soon learn that the art of using complementary colours successfully involves ratios – one of them should always be weaker than the other. For example, a bright red flower will be 'lifted' by pale green foliage, or intense blue sky complemented by a light-coloured orange sun.

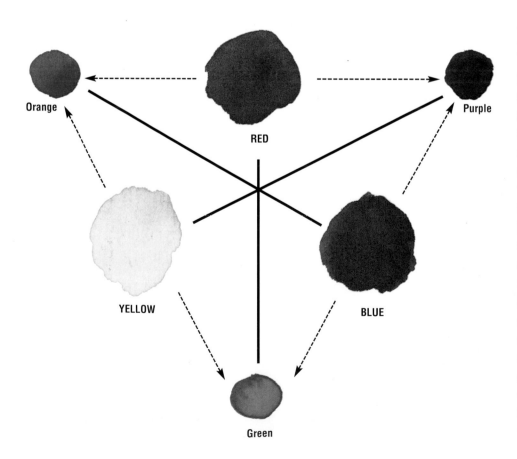

Mix 'n' match

This diagram shows the relationship between primary and complementary colours at a glance. The broken lines leading from each primary colour (red, blue and yellow) show the colour that results when any two are mixed: red and blue make purple; red and yellow make orange; yellow and blue make green. The pairs of complementary colours are indicated by unbroken lines: red and green; blue and orange; yellow and purple. This is a very simple equation, but one that can make an enormous difference to your work. You can make any number of rewarding combinations by experimenting with the varying shades of each complementary pair. The 'attraction of opposites' works well when mixing complementary colours together. Dulled colours produced by mixing complementaries work well with each other in a composition, because each will contain some of both pure 'parent' colours.

Local colour

After studying this farmstead nestling snugly in the landscape, I decided the dominant orange colour of the tiled roof offered a splendid opportunity to inject atmosphere into the composition by making extensive use of complementary colours. Because the orange was so strong, I made sure the complementary blues did not compete. The hill behind the farmhouse was defined with the palest of blue washes. The barn and shadow to the left were made slightly stronger, with pale complementary orange washed in. The use of yellow (one 'parent' of the orange) in the sky serves as a reminder that an appropriate primary can add an effective dimension to any picture that makes extensive use of complementary colours.

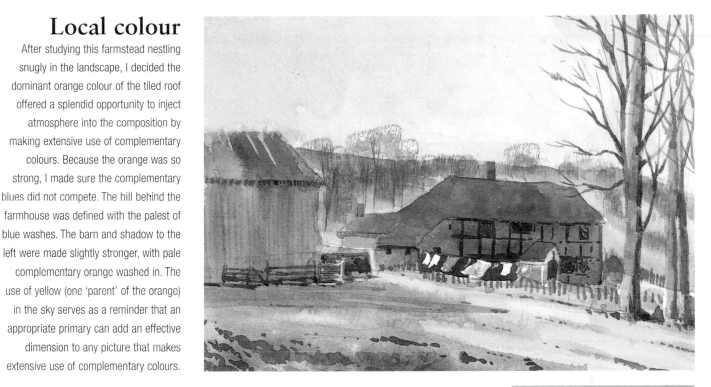

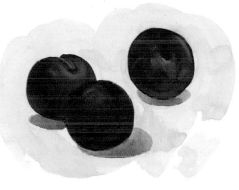

Purple patches

As the decoration of many a rebellious teenager's room has proved, the powerful combination of full-strength yellows and purples can have a dramatic impact. This reminds us of the important rule that complementary colours used at equal strength create vibrant discord. In order to set off these rich purple plums to perfection, I chose a light, creamy yellow background that complements the richly coloured plums rather than competing with them.

TEACHER'S TIP

When considering a subject and are unsure which of the complementaries you are seeing, ask yourself which primary colour that subject most resembles. So a buff road would be closest to yellow, allowing you to use a lavender grey (a soft version of purple) for complementary shadows cast across the road. Or pink sky would work well over a strong green fields.

Complementary shadows

The use of complementary colour in shadow areas is an excellent technique that can add life to a picture. This simple still life of a red clay flowerpot is set off by the long green shadow, and a faint green background line is used to give the composition a context. I also mixed a little green into the red wash to darken the shadowed side of the pot and establish the light source. This illustrates a valuable general principle – if you mix a colour with its complementary, you will find that the result is a very lively grey.

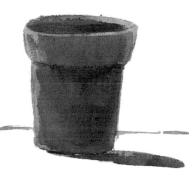

Go for granulation

An interesting tonal effect can be achieved with colours that 'granulate'. Some colours separate when laid as a wash – including most earth colours, cobalt, cerulean blue and French ultramarine. For the test strip, I used cerulean over dry orange wash – a good complementary combination. Use this technique for spectacular skies.

Harmonious colours

We have looked at the way in which complementary (or opposite) colours can be used to affect the mood of a painting by injecting movement and energy. Now it is time to consider the contribution that can be made by harmonious (or analogous) colours – those which are close together on the colour spectrum. Unlike the attention-seeking chromatic conflict induced by those 'clashing' complementary colours, the use of exclusively harmonious colours will – as the name suggests – help you to achieve a much more peaceful,

contemplative mood in the finished work. At one end of the colour spectrum, the choice is blues, purples and greens. At the other, you will be working with reds, yellows, oranges and browns. Painting a picture that concentrates on the use of harmonious colours does not have to be at all restrictive. While it may involve extensive use of similar colours, especially when choosing those from the 'blue' range, you can achieve great tonal variety by mixing your chosen colours – confident in the knowledge that these

'close relations' will mingle well and have a bright and clean final appearance, because there is no 'outside colour influence' to dull them. For those who find difficulty in mixing colours that seem to work for them, any mixes of analogous colours will tend to combine successfully. By choosing to concentrate on a harmonious colour scheme, you can greatly enhance the sense of coherence and unity within the completed painting.

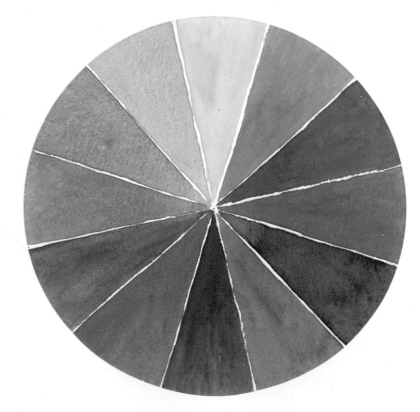

In harmony

The colour wheel has the three primary colours of red, yellow and blue arranged at an equal distance from one another. Between each pair of primaries fall the graduated colours made up by mixing those two primaries. The wheel provides an 'at a glance' guide to the way colours work together. Complementary colours appear opposite one another on the wheel, analogous or harmonious colours are close together. It is worth making your own reference wheel by mixing the different colours from your box in various combinations as – depending on the specific paints you use – the results will differ from printed versions. You do not have to paint a neatly segmented wheel – just arrange the appropriate splodges of colour in a loose circle. For the primaries on this typical wheel, I used cadmium yellow (at 12 o'clock), alizarin crimson (4 o'clock) and French ultramarine (8 o'clock). You might prefer alternatives like lemon yellow, scarlet lake and cobalt blue respectively. The chromatic colour wheel can contain only pure (or 'intense') colours – it must never include unsaturated colours such as brown oxides, indigo, sepia or yellow ochre.

| Raw sienna | Azo yellow | Cobalt | Burnt sienna | Payne's grey | Rose madder |

Warm cheeseboard

This still life has been based on colours at the 'warm' end of the spectrum – yellow, brown and red. But it is interesting to note that I have also decided to use colours that fall outside the immediate 'family' – cobalt and Payne's grey. This illustrates the important point that the sort of calm integrity achieved through the exclusive use of harmonious colours within a picture need not be destroyed if 'outsiders' are incorporated into the composition. The Payne's grey is neutral, and the cobalt has been laid over warm colours, toning it down beyond the point where it could make a clashing statement. This allows the faint blue tinge to make a positive contribution to shadow areas.

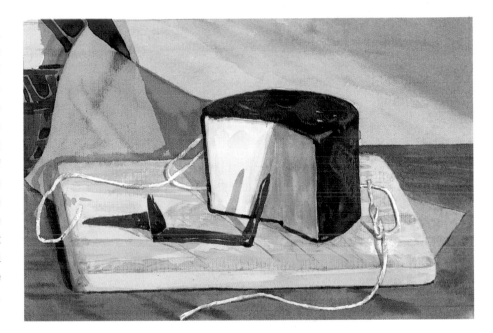

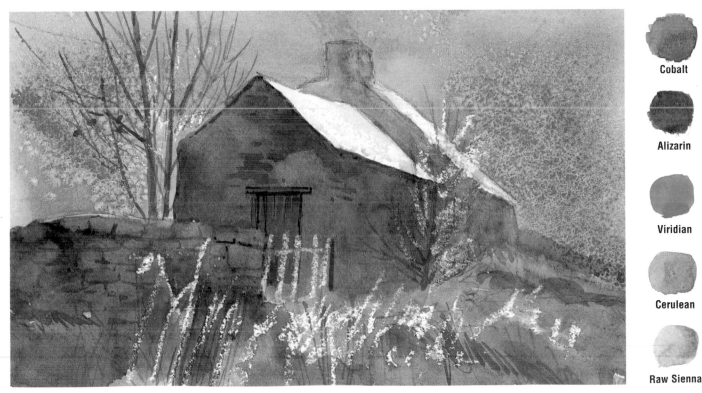

Cobalt

Alizarin

Viridian

Cerulean

Raw Sienna

Cool barn

This winter landscape has been based on colours at the 'cool' end of the spectrum – blue, green and mauve. Salt was sprinkled on the sky and wax to the trees and gate to add texture and emphasize the frosty feel. Again, I have used warmer colours (raw sienna and alizarin) but these have been cooled down with glazes of viridian so they do not detract from the harmonious image.

Colour temperature

After seeing how the intelligent use of complementary and harmonious colours can affect the mood and feel of a finished picture, you should consider the potential impact of colour temperature on watercolour painting. As a general rule, colours on the blue section of the colour wheel – from violet round to green – are described as the 'cool' family, while those in the red section – from purple round to yellow – are the 'warm' family. Blue-green and red-orange are respectively the coolest and warmest colours. At its simplest, you can set the 'temperature' of a picture by choosing appropriate colours – for example to communicate the heat of a summer afternoon, or the chilly atmosphere of a hard winter morning. The considered use of colour temperature can add considerable impact to your work, because you manipulate the viewer's psychological perception. But it is a mistake to assume that blues will *always* give a composition that cool look, or reds a warm feel. The secret lies in positioning. For example, purple next to red will seem warm, but purple next to orange will appear cooler. There are also gradations of colour temperature within the warm and cool families. Every basic colour can have both a warmer and cooler version. Thus, a cool red may be created by adding a touch of blue and a blue warmed by mixing in a dash of red. Psychologically, the use of warmer colours tends to attract attention, heighten emotion and generate excitement – red is, after all, the attention-grabbing 'danger' colour. Cool hues are clean, refreshing and have a calming effect. Intermediates like violets and greeney yellows will give a moody atmosphere.

Blowing hot or cold

This harmonizing wheel has cool shades on the outside, warm equivalents on the inside segments. I painted the outer ring (from the top clockwise) using: Winsor lemon, Winsor lemon + alizarin crimson, alizarin crimson, alizarin crimson + Winsor blue, Winsor blue (green shade), Winsor blue + Winsor lemon. The corresponding inner ring was: cadmium yellow pale, cadmium yellow pale + cadmium red, warm cadmium red, cadmium red + warm French ultramarine, warm French ultramarine, warm French ultramarine + cadmium yellow pale. Oranges are the hottest colours, mid-greens the coldest.

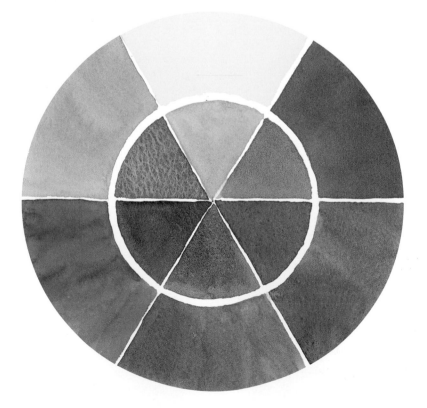

TEACHER'S TIP
In order to achieve warm or cool effects when using washes, make them strong. It may seem that you have overdone the colour saturation as the washes are first applied, but you will soon see the reason. Watercolours pale as they dry, so it is easy to underestimate the colour strength needed.

Desert heat

By pushing related warm colours to extremes, I have achieved maximum impact in this desert landscape. Baking heat can easily be conveyed using reds and yellows. Even the shadows seem (and were!) hot. Raw sienna was laid as a pale wash over the sky. Azo yellow was painted strongly over the land mass. Rose madder with some raw sienna and a little Winsor blue were used to make the shadows that defined the rocky outcrops. Finally, rose madder and Winsor blue were laid over the foreground azo yellow to create the area of warm, dark shadow. The cool blue adds depth to the shadows without detracting from the overall feeling of searingly dry heat.

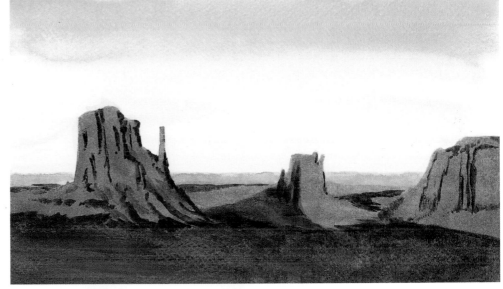

Azo yellow **Rose madder** **Raw sienna** **Winsor blue**

Viridian

Cobalt

Alizarin

Azo Yellow

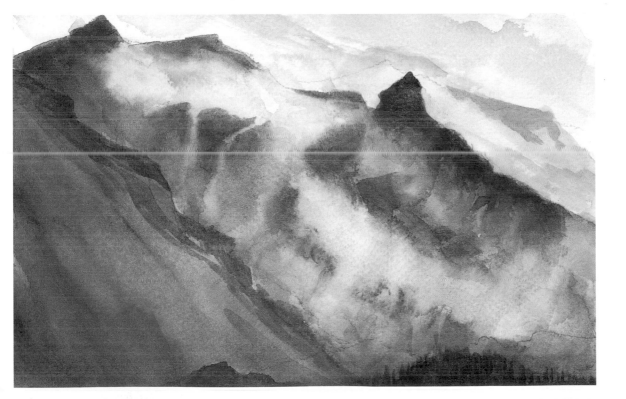

Mountain chill

To create the chilly feel of mountain mist on a day that promised little sun, a range of predominately cool colours was used – cobalt, viridian and alizarin. I did apply an initial wash of azo yellow, but this provided lighter highlights without losing the cool overall feel. The mountains were laid with a large brush dipped variously in cobalt, viridian and rose madder. Although the latter is another member of the warm family, it is towards the cooler end of the range. Using wet-into-wet technique, water was laid in valley areas as the colours were running together, which spread to make the mist when I tilted the paper. Darker passages of cobalt and viridian were applied when the painting dried to complete the icy feel.

Setting the tone

TEACHER'S TIP

Getting the tones right within a composition can be challenging. If you are not satisfied with the results you are achieving, and feel unsure whether or not your tones are generally working as well as your colour, try this simple but constructive test. Photocopy one of your paintings in black and white. If it does not copy very cleanly, giving crisp definition and especially good contrast value, the chances are that you are not working your tones properly. You should therefore concentrate on improving this vital aspect of your technnique.

It is said that on one level the choice of colour does not really matter, because a compelling picture can be painted in any colours – providing the tones are accurate. This may be an exaggeration, but I often suggest to my students that they should try doing some test work only in monochrome to improve their tonal technique. It can be an enjoyable exercise. Select a colour that will give sufficient dark tones when you need them – Payne's grey or black are good choices, as too are burnt umber, Vandyke brown, sepia and Winsor blue. Work from light to dark, as you would normally do. The result may turn out to be a very satisfactory picture in its own right, rather than a worthy

but boring exercise. The use of strongly contrasting tones will make your pictures much more dynamic, with the play of strong light and bold shadows giving the subject matter a powerful three-dimensional feel. If you are aware of this effect, it will help you create more successful work when painting by sunlight. Look for prominent shadows and consider how their shapes might be used to make a positive contribution to the composition. Shadows can also be used to direct the viewer's eye towards an interesting part of the scene. It is no accident that many great painters in the past consistently used strongly shadowed foregrounds to help the eye into the well-lit middle distance, where all the serious 'action' was taking place.

TEACHER'S TIP

The arrangement of tone is critical to the success of a painting. Look for interesting blocks of light and dark when assessing a composition. Also bear in mind that strong colours tend to *advance* while pale colours *retreat* – an effect that may be used in conjunction with tone to emphasize or subdue elements of the scene.

Little grey rabbit

This lop-eared fellow has been entirely created with the use of tone, and very effectively it renders him. The dark background echoes the rabbit's shape and gives a strong three-dimensional feel to the composition, while detailed definition of the head and ears is a study in tonal contrast. Further grey washes and a few bold brushstrokes convey the animal's furry texture.

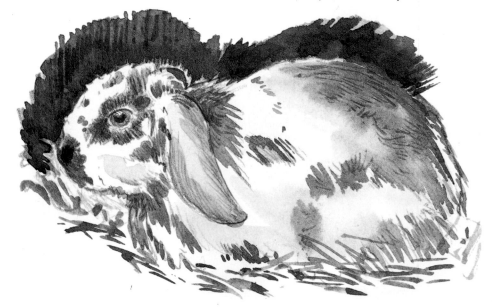

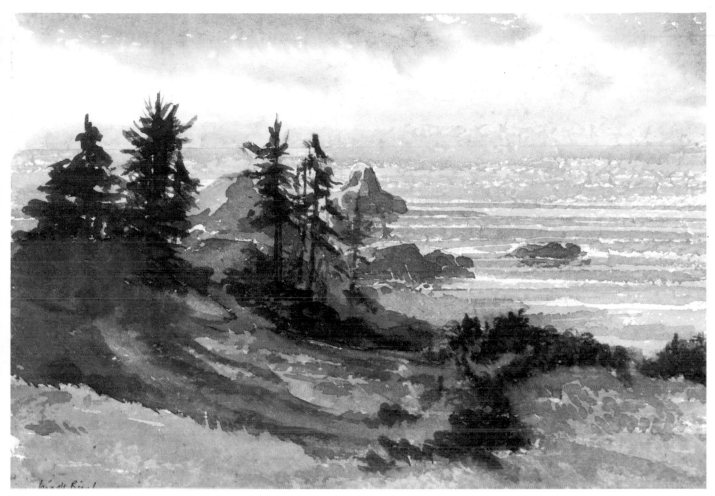

Oregon pines

This picture of the spectacular Oregon coast was painted on a windy day. I liked the brooding presence of the pines and wanted to stress highlights where the sun was catching the sides of the distant rocks. Their pink colour complemented the blue-green of the sea. I simplified the pine trees into dark silhouettes and also shadowed the foreground. This strong tonal contrast 'pushes' the eye into the picture and through to those fascinating rocks.

On the wild side

One afternoon in Israel's Negev Desert, the pronounced contrast of the sunlit and shadowed rocks in the foreground caught my eye. This striking tonal value was made more interesting by the blue shadowed valley behind. Here, I was able to make use of two different techniques – combining the complementary blues and oranges of this imposing landscape with the wonderful contrasts created by burning sunlight falling on the fascinating shapes of the eroded desert monuments.

Playing with colour

Play around with colour and see where it leads. I study the work of artists whose reputation has stood the test of time, to try to understand why their work is so enduring – and learn lessons that will help me with my own work. Never be afraid to look at classic techniques such as colour weaving or the methods developed by schools like the Pointillists and Impressionists. They produced inspirational work and, while not suggesting for a moment that you might want to base your style on that of others, I do believe artists should constantly explore new ideas (even if they may actually be old!) that can stimulate them into pushing their work to ever-greater heights of creativity.

Threading fire

I wove the fiery sunset through this picture to relate all the colours to each other – a technique that works with any dominant colour. The hot red and its reflection becomes an integral part of the painting. The red was was laid first, all over the picture. Other colours were washed over the top, allowing the red to come through where relevant to hold the composition together.

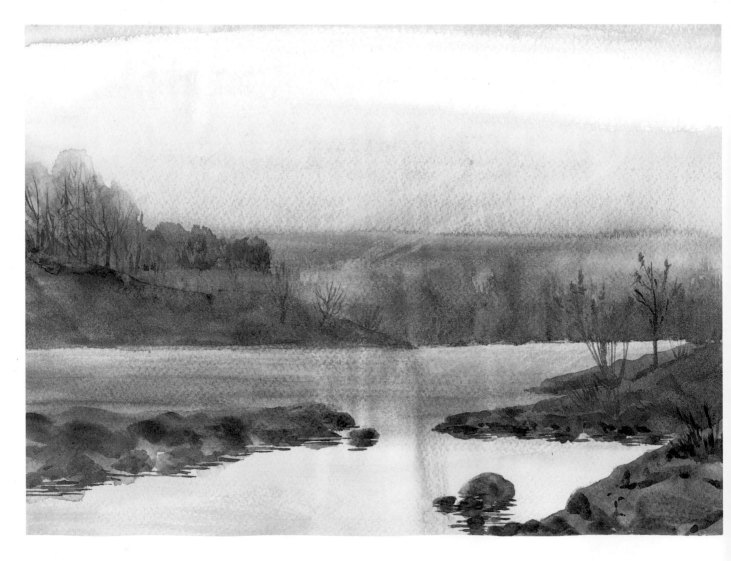

Dotted lemon

The Pointillists used dots of colour to build pictures. When viewed from a distance, colours appear to merge into solid colour and tone. I borrowed the method to create this lemon. The form was covered with tiny dots of lemon yellow, followed by dots of cadmium yellow deep in all areas except the lightest part. Raw sienna was dotted into the shadow area, followed by alizarin red and cobalt blue. The colours fit together like a complex mosaic. The background and shadow were worked in the same way, using dots of all colours except the two yellows

TEACHER'S TIP

If you want clear and brilliant paintings with rich, dark contrasts, banish black and grey from your box. These opaque monsters can have a 'deadening' effect. Try mixing them from other colours for a more subtle and satisfactory result. But do not ditch the white from your armoury. The essence of watercolour painting may be translucence, but the use of opaque white can be justified under certain circumstances – for example, when restoring a lost highlight or adding substance to rich colour that requires a denser feel. A little white need not destroy the integrity of your watercolour.

Freesia impression

This was worked using the Impressionist method of placing brushmarks of colour side by side so they mix optically when viewed from a distance. The theory was based on carefully observing the effects of colour, light and shade. Rather than overlaying washes of colour in traditional watercolour mode, in my modern interpretation, I painted the flowers using different colours and tones, placed together in a way that makes them 'melt' together. The colours used were lemon yellow, alizarin red, cadmium red, cobalt blue and raw sienna. By looking to the past for inspiration, I have created an interesting and rewarding picture.

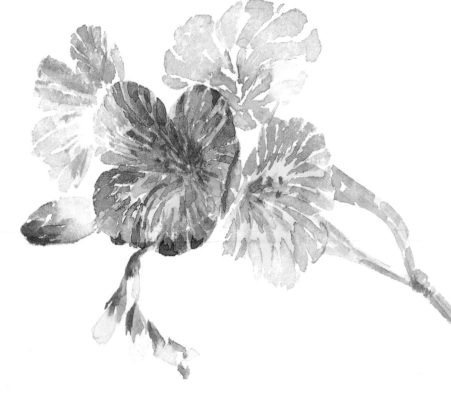

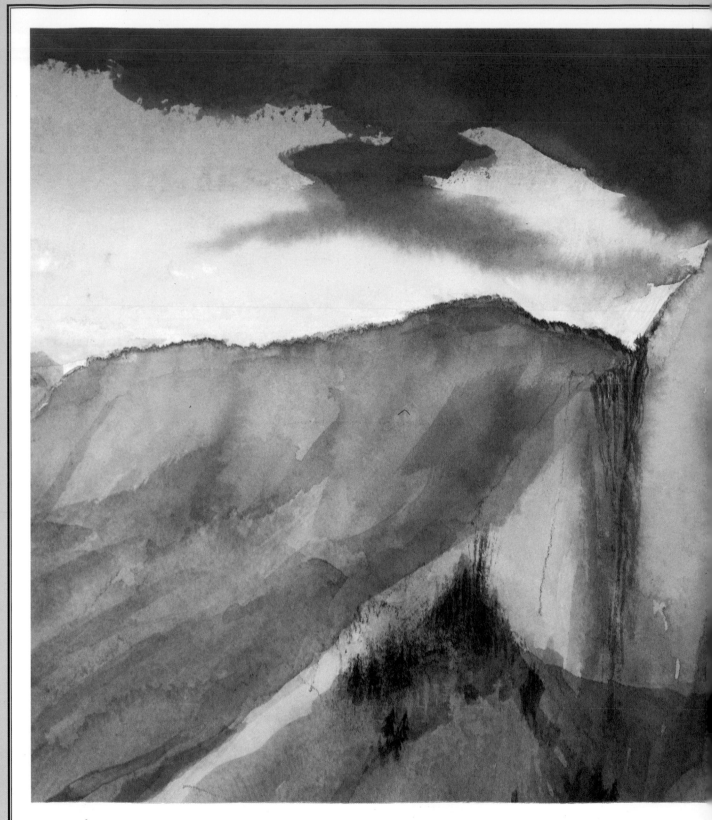

Burning mountain

The same scene can look very different as light conditions change, so try and choose the moment that complements the mood you are seeking – if necessary by observing a subject at different times of day and in changing weather conditions before starting work. To capitalize on the mountain's imposing shape, I waited until it was highlighted by setting sun, causing the rocky flanks to blaze with evening light. The 'smoking' cloud effect was a bonus. To make the most of warm lighting, I made sure the subdued foreground didn't compete and led the eye automatically to the painting's focal point.

Dynamic light

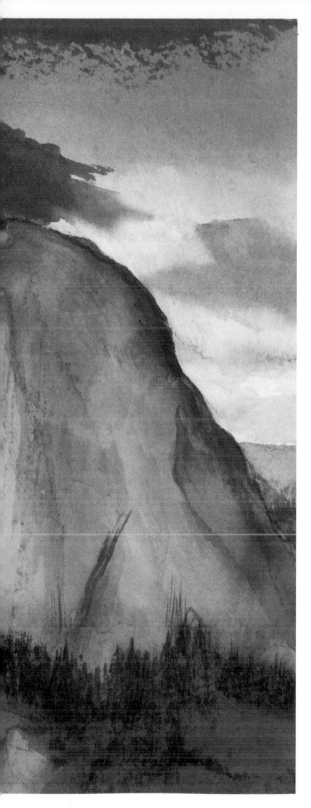

If the lighting is dramatic, a painting will arrest attention. Light is a key element in painting. As well as giving definition and clarity, light has a dynamic quality that adds something, imparting energy and bringing a picture to life. Without keen appreciation of the impact that can be achieved by skilful use of eye-catching light effects, your work will be in danger of falling flat – however good your sense of composition, feeling for colour or mastery of technique may be.

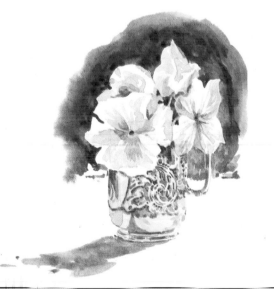

Silver swirls

As the sun moves, shadows follow. I painted shadow areas first before conditions changed. I used the silver beaker because light bounces off shiny surfaces to produce interesting reflections – nearby objects reflecting in the beaker created a swirling pattern and a hint of colour.

The quality of light

What is light? It's one of those questions that hardly seems worth asking because the answer is so obvious – until you try to put it into words. Luckily you don't have to, because you're a painter. Light is not a tangible thing that can be held in the hand or captured in a bottle, yet this vibrant entity is an essential ingredient of every watercolour ever painted. Light and shadow are like Siamese twins – neither can exist without the other. The stronger (or weaker) the light, the stronger (or weaker) the shadow. The watercolourist therefore uses shadow to indicate both the source of light and its strength – strong, bold shadows suggesting intensity of light, while subtle shadows convey soft light. But there is more. Light has a tremendous impact on mood – imagine a romantic dinner under floodlights rather than by candlelight! The same can happen in a painting. If the quality of light is wrong, or inappropriate for the subject, the finished result will appear unsatisfactory. Beyond the correct rendition of lighting, you should always be looking for light conditions that might add a distinctive feel to your composition, or even inspire it – a dull landscape that seems uninteresting beneath the noonday sun might appear sensational at dawn or by the cold light of the moon.

> ## TEACHER'S TIP
>
> Nothing ruins a painting more surely than shadows falling at an inconsistent angle from the light source. Depending on the direction they lie (towards the eye or away), shadows are wider or narrower than the object being shadowed and are subject to the normal laws of perspective.

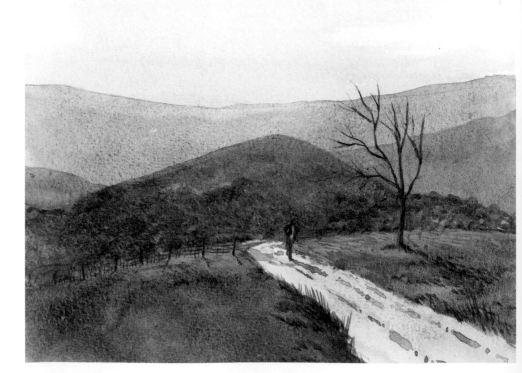

Remains of the day

Evening time often produces very atmospheric lighting conditions, as here. The sun has fallen behind the far hill, leaving a warm glow in the western sky. As dusk approaches, colour drains from the landscape, turning the distant hills to subtle shades of grey. The last of the daylight is still strong enough to illuminate the dusty track and leave a hint of colour in the foreground. To capitalize further on the powerful mood created by this diffuse lighting, I added the solitary homebound figure.

Sunshine and shadow

This back yard with daisies is another example of the way in which interesting light can 'make' a picture. I might not have chosen to paint this subject without the shadowed areas in the yard, which added an extra dimension by providing strong contrast with the bright clump of sunlit white flowers in the foreground. For the shadow colour I used a purple-grey mix that is a near complementary to the honey-coloured stone, creating a harmonious background colour balance that sets off the daisies to good advantage.

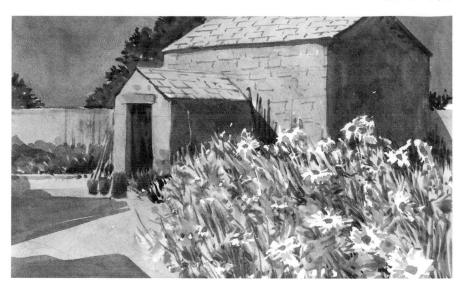

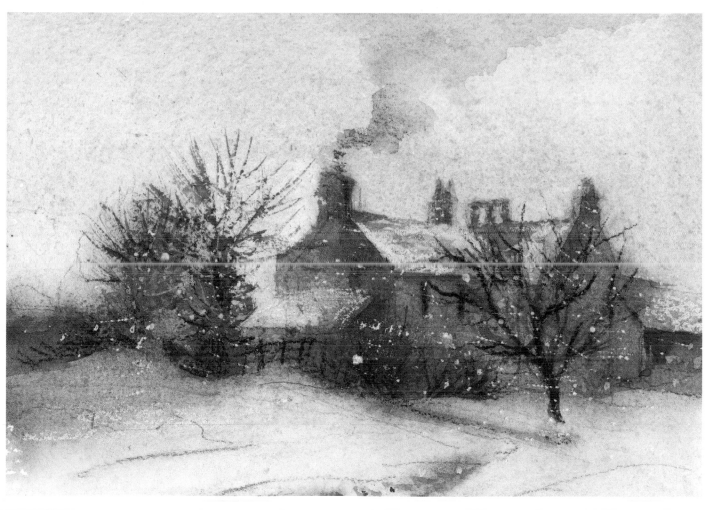

Winter whiteout

A snowstorm produces intriguing light. The world takes on an eerie appearance and colours become subdued. Beyond that, falling snow creates a mood of excitement and a sense of being alone with the elements. The snow whirling about this old farmhouse was irresistible, not least because rising smoke hinted at a blazing log fire within! I used a limited palette of colours to create the monochromatic effect of a snowstorm, working wet-into-wet to obtain a soft, misty feel. To give the snowstorm dynamic presence, detailed forms were created as the paint dried. Flecks were added last and a knife was scraped over the surface to give the snow 'driving' movement.

The direction of light

Nothing has more influence on the outcome of a painting than the placing of the light source. If the lighting is really interesting, colour can take second place. In certain lights – particularly when light comes from behind the subject – colours seem almost monochromatic. This can create a tremendous sense of atmosphere and drama. Alternatively, light from the side can be used to generate a feeling of brightness and movement, by causing flickering shadows or dancing highlights. Pronounced shadows can become an important element in their own right or – by stressing the strength of the light that created them – allow you to use saturated colour that would look out of place in weaker lighting conditions. Frontal lighting tends to reveal strong, flat shapes with well-lit detail. Choosing the optimum direction of light can turn an ordinary composition into something altogether more dynamic.

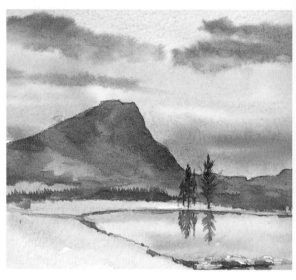

Mountain magic

This Rocky Mountain landscape shows how the direction of light can completely alter the feel of a similar subject. It is a snow scene like the one pictured left, but low winter sun underlights the sky, creating shadow on top of the clouds. After laying in the background wash, this effect was achieved by adding a touch of raw sienna and yellow ochre to the underside of the cloud area when the sky was still slightly damp, to render soft cloud edges. I mixed a stronger solution of grey for the clouds, blending into the yellow. The warm sky is reflected in the frozen lake, while the mood of the picture does not require the snow-bound forest and shore to be shown in any detail.

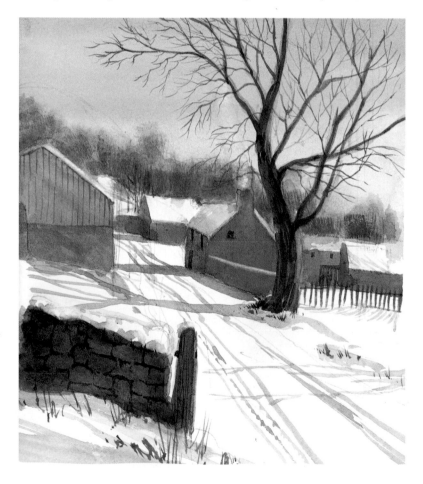

Sunshine and snow

Sunlit snow scenes make fascinating subjects, because the light has an extraordinary clarity that makes everything seem bright and clean, imparting an instant itch to the painting hand. For this farmyard near my home, I chose strong sidelighting, allowing me to use sharply defined shadows on the snow that 'laced' the composition together. When the countryside is covered in a dazzling white blanket, reflected light can create wonderful effects. But it's easy to be carried away by striking contrasts and 'overpaint' shadow. I use cobalt for transparent shadows on snow, so they don't appear too heavy and unbalance the picture.

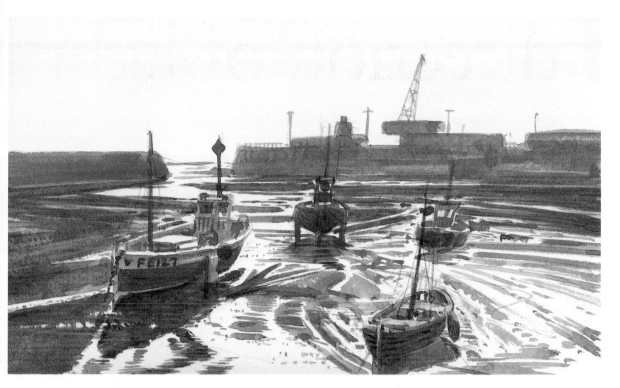

Harbour light

This is a classic contre jour composition, with a light source at the back of the picture that casts shadow towards the front. This lighting is exciting when it strikes objects, tipping them with light. Form is indicated by small amounts of strategically placed light, and colours are muted. This has the effect of rendering very subtle shadowing. To begin, I washed the pale-yellow light colour over the whole picture. When dry, I superimposed shadow colours on top, leaving a trail of light that leads the eye forward. I applied a limited range of colours, making a series of greys for the boats, jetties and mud. Even the red hulls and tender that add a splash of colour were deliberately muted.

On the house

By way of contrast, this frontlit waterside scene called for a different approach. Here, high sun was shining from behind my right shoulder. The white boathouse with its angular shape was brightly lit, making a natural focal point. At the same time, the receding jetty and walking couple lead the eye towards the estuary beyond, creating a sense of open space beneath the big sky. From there, the eye returns to the highlighted boathouse and on to the rowing boats stranded on the mudflats. Even in this hard lighting, however, I did not feel the need to use bright colour, which would have been inappropriate for this wind-seared place.

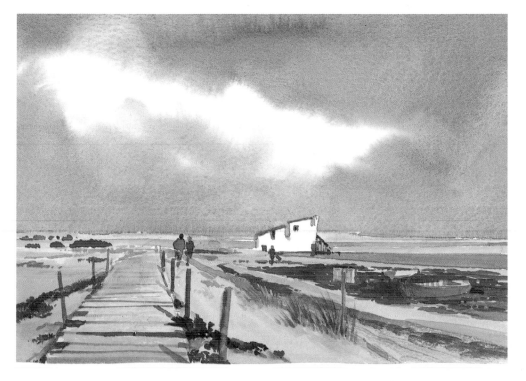

Moving light

It can be difficult enough to position the light source to maximum advantage when planning a picture. Once chosen, however, you will at least be working with relatively consistent lighting conditions. But sometimes capricious light can be anything but stable. The watercolourist can face few more demanding challenges than the depiction of moving light – yet the effort is justified. Dancing shadows or light on windblown foliage, sparkling water or sunlight playing hide-and-seek with scudding clouds, shimmering reflections or the glowing coat of a galloping horse – moving light invites the artist to create a composition with an in-built sense of vigour and excitement. When faced with such a scene, the task of capturing that lively quality may initially seem daunting. But it need not be off-putting, if you fall back on the basic rule that the light in any composition is expressed and defined on paper through its inseparable twin: shadow. The imaginative use of shadow can give the strong impression of dynamic light and help you to produce more interesting work. Do not be afraid to experiment – it may take a few failures, but if you learn to 'light up' your pictures the effort will be worthwhile.

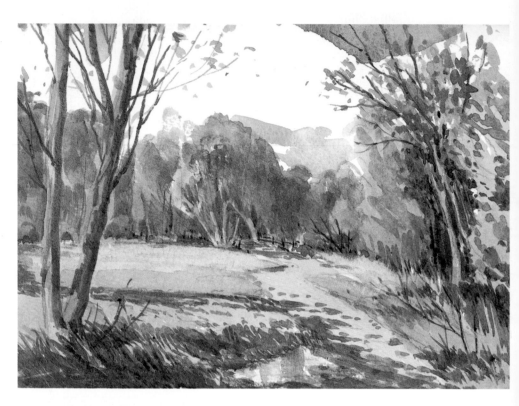

TEACHER'S TIP

If you're doing a still life by natural light that requires several sessions, paint at the same time each day, when the shadows will be consistent – equally valid if you are painting a landscape. Should you be unable to return and complete your picture on another day, make a tonal sketch or take a photograph to help you finish.

Blowing in the wind

This depicts one of those fresh summer days when a gusting wind is tossing the treetops. I chose a viewpoint looking out from the wood to the sunlit meadow and trees beyond, because I was drawn to the dappled light and the way in which broken shadows were making an agitated pattern on the track. Strong sidelight created a counterplay of light and shadow that was itself dynamic, but I increased the sense of movement by having the foreground trees leaning into the painting and adding one or two whirling leaves that had become detached in the wind.

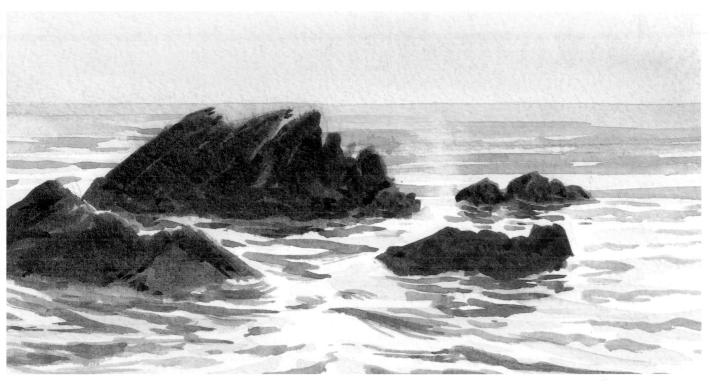

The restless sea

As evening approached, the sun fell behind the far horizon and for a few brief moments the light had remarkable clarity. The contre jour effect muted the colour, though the roseate hue of the sky (reflected in the immediate foreground) gave warmth to an otherwise cold and glittering scene. The sea seethed around the rocks, breaking up into a mosaic of light and shade. I achieved the impression of moving swell by painting the water with a minimum number of irregular strokes, letting reflected light create a sense of movement.

Shadow dancing

Interesting pictures can be created by making shadow an integral part of the composition. I placed this house plant on the broad ledge of a stone-mullioned window and opened the left-hand casement. The morning sun provided bright 'floodlighting', casting a variety of conflicting shadows. A breeze ruffled the leaves, casting a moving shape on the wall. I captured that sense of movement by painting a shadow which looked almost like a dancer, and led the eye to this interesting feature by slightly 'angling' the shaded area behind the container.

Dramatic and colourful light

To me, one of the delights of watercolour painting is the way in which this delicate medium lends itself to subtlety – of light and shade, colour and contrast, tone and texture. But we must all have seen and been moved by a blazing sunset or some dramatic light show in an angry sky . . . and wondered if we dare presume that the awesome moment might be captured in a painting. Why not? There are times when Mother Nature is anything but subtle and I am always prepared to take her on at her own game. It can be a somewhat dangerous pastime – working with the strong light effects and saturated colours of a spectacular sunset is not easy, and the artist will always be treading the fine dividing line between the merely colourful and garish. By the same token, those lowering clouds can become oppressive rather than impressive, overwhelming the showy light effect that attracted you in the first place. So be prepared for a few failures – but if at first you don't succeed it is worth persevering with these overtly colourful or dramatically lit compositions, because when everything comes right the outcome can be an intensely satisfying painting.

Raising the game

Due to the linear characteristic of light, shafts appear to fall in straight lines. This phenomenon is often seen in cloudy, backlit skies or where the sun's rays are falling through trees to the forest's shaded floor. Without the bright shafts connecting sky and land, this picture might have been overwhelmed by heavy cloud. As it is, the presence of those light shafts injects drama that lifts the composition. In fact, I painted this without the shafts. When dry, I created them with the help of a paper stencil consisting of a narrow channel. A soft, wet brush was used to loosen the paint, which was then blotted off with a tissue.

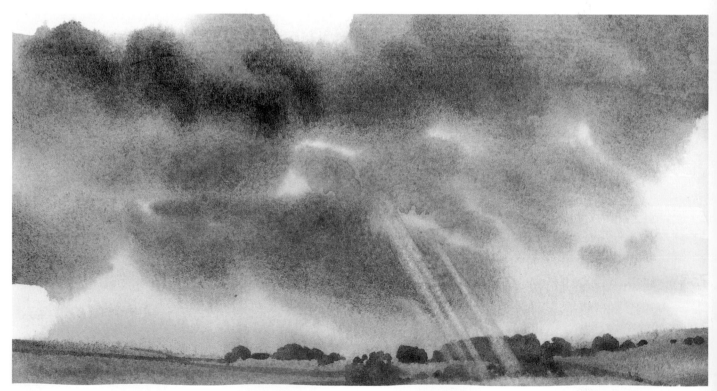

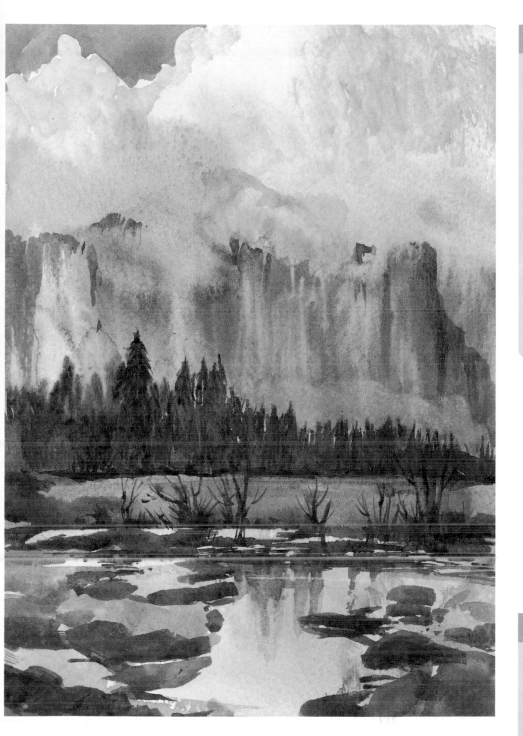

Sunset spectacular

If ever there was a boldly coloured production number, it is this fiery sky that inspired me in Yosemite National Park. This is sunset time, but might have been earlier. In the northern hemisphere, low winter sun often lights the clouds from below, leaving the tops in shadow and creating a 'sunset effect' during the day.

TEACHER'S TIP

Unless you set up a subject in controlled lighting, dramatic light conditions that tempt your eye will be unusual, even unique. A Polaroid photograph can help you 'capture the moment' in case conditions should change before the painting is completed, allowing you to finish the picture as intended – on the spot or later on.

TEACHER'S TIP

Don't assume the first view you see when the lighting conditions are dramatic is necessarily the best. For example, those who prefer to 'stay subtle' rather than essaying a multi-coloured sunset should turn their backs on the main show and study the eastern sky, where some very delicate reflected light effects sometimes appear.

Contrasting light and shade

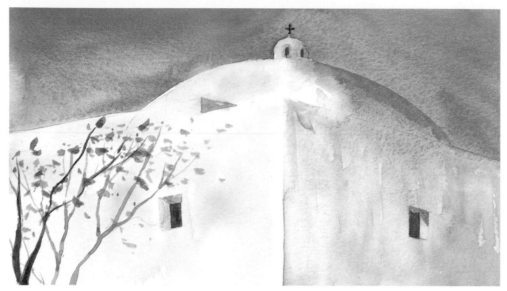

We have seen that the twins – light and shade, sunshine and shadow, bright and dark – can be the watercolourist's best friends. And they are pretty sophisticated characters. We have already explored the way in which all sorts of interesting light effects can be created and defined by the strategic use of shadow, bringing an extra dimension to the finished watercolour. Now it is time to consider what a valuable contribution featured shadow and shade themselves can make as a principal element within a painting. Extreme contrasts often produce interesting

Sprinkled shadows

This squat Greek Orthodox church is a classic study of simple contrasts – its rounded dome against deep-blue sky, a single window in each wall hinting at cool darkness within the thick walls, one side illuminated by the sun and the other in reciprocating shadow. That alone was not enough, but the sprinked shadow effect thrown by the foreground tree adds interest and weight to the composition, balancing the strongly lit, solid forms of the walls.

Midday in Marrakesh

In this busy scene, a strong sun shines directly down on the marketplace. Such conditions tend to highlight colour and permit the use of brighter shades that would be entirely inappropriate under less stark lighting conditions. At the same time, contrasting sunshine and shadow allow you to avoid neutral shades and tip shadow greys towards a colour, with a view to creating exciting effects – an opportunity I used to full advantage when painting the shaded background that sets off the vibrant figures.

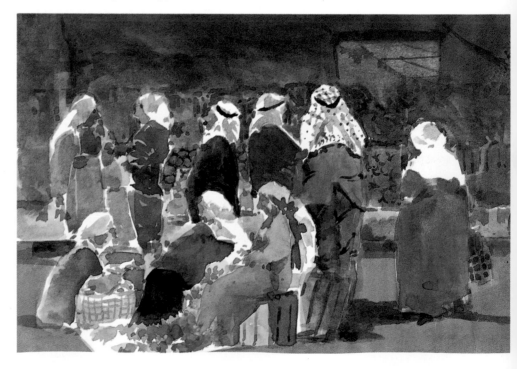

opportunities where shadow can become an integral part of the composition. Strongly lit subjects give the maximum tonal contrast at opposite ends of the light scale – the brighter the light, the deeper the shadow. But 'deeper' should never be equated with 'darker'. On the contrary – the treatment of areas of deep shadow offers imaginative possibilities, allowing you to paint shaded areas much as you might create a dark sky, with a varied selection of tonal effects and hints of complementary colour picked up from the rest of the picture's subject matter.

TEACHER'S TIP

When working from a reference photo, be aware that the camera interprets shadows very crudely – often as solid black shapes. The human eye discerns more subtle tones, which should be reflected in your composition. Allow for this by making specific colour notes on site, after taking the original photograph.

Back view

This sunlit back alley really appealed to me. I was studying interesting light patterns and thinking they might make a fairly mundane street scene into a worthwhile picture. Then the old Greek woman hurried by with her mysterious bundle and my mind was made up before she was out of sight. Here, shadows are not merely used to define the bright morning light, but become essential elements of the composition, giving me the chance to use subtle complementary colour and strong texture – the foreground shadow is almost like a dimpled pool that 'reflects' the ancient wall.

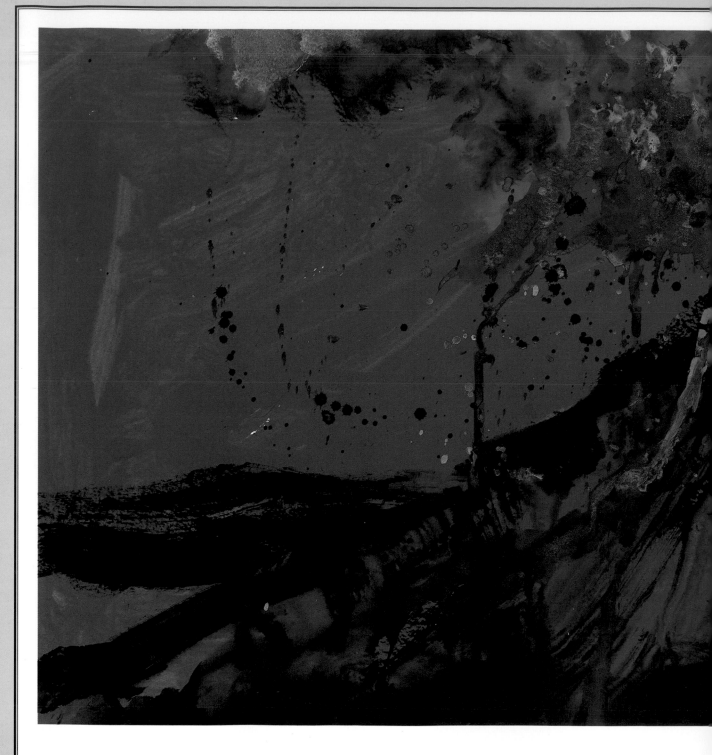

Explosive energy

Watercolour, gouache and salt

This was painted on a coloured paper, using an old stiff-haired brush which makes good textural marks. Water was dropped onto the volcano's surface and red paint applied, tilting the paper to encourage lava flow down the hillside. White gouache was used to create smoke and lighten reds and yellows so they appear bright on the dark paper. Card was dragged across to create craggy rock texture and the spurt of flame. Salt was dropped into the grey smoke as it was drying to depict fine ash and cinders. More cinders and rocks were made by spattering paint over the surface. Incidentally, do not hesitate to be ruthless in the quest for drama in your work – on the back of this dynamic picture is a more gentle landscape that I abandoned because I simply was not excited enough about the way it was turning out.

Dynamic expression

You need not always choose dramatic subjects in order to paint dynamic watercolours. That's why the volcano is accompanied by placid pomegranates – the sort of simple still life that might be chosen by any art class. All you need is the vision and confidence to believe you can bring something special to any painting you tackle. Using techniques explored in this book, the paintings in this chapter cover popular subject areas and show how I tried to bring dynamic expression to each picture by seeking interesting and original approaches.

Textured temptation

Watercolour and ink

How do you make your pomegranates stand out? Here, to capture the skin quality, I used rough watercolour paper with a coat of white ink (acrylic would have served equally well). Ink was brushed on to create a waterproof surface. When dry, colour was applied thickly using only enough water to make it adhere to the resistant surface. The result is distinctively textured pomegranates that look good enough to eat.

Landscape

We all want more from our landscapes and fear they may be dull and predictable. But even the quietest pastoral scene can become a dynamic picture. Always be on the lookout for possibilities, and remember that time spent in observation is as valuable as time spent putting paint on paper. Keep looking until something catches your eye. Think about what attracted you. Consider which technique might best capture that elusive quality. And finally ask this – are you so excited that you *must* try it? It may be satisfying to know you have the ability to render any subject well, but the best paintings are those that spark your creative imagination, rather than merely presenting an opportunity to exercise technical skills on an attractive subject.

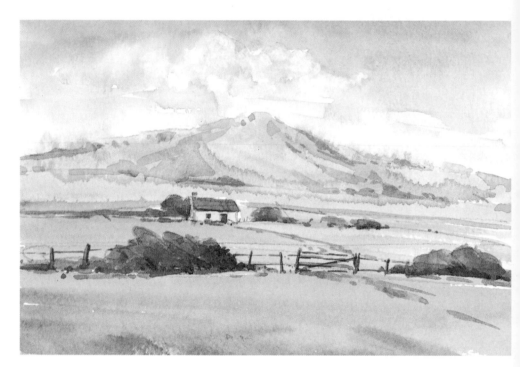

Croft house

Watercolour

Not every picture has to be a production number – one of the joys of watercolour painting is an ability to 'capture the moment'. This vista might attract any artist, and the choice of rough paper complemented the rugged landscape. But the special quality lay in the unusual sky colouring, which was painted quickly using a basic wash technique suited to recording rapidly changing weather or light conditions. As the aspect that most appealed to me, the pink sky was laid first as a wash and darker background sky colour added on top.

Autumn day

Watercolour

Using complementary colour can lift a painting. I might have passed by this typical autumn scene, but orange foliage against a blue sky caught my eye – an arrangement of complementary colours. I used a medium-sized round brush to paint the main colours crisply, adding trunks and branches after the foliage. I made one colour stronger in tone than the other: had I pitched them equally, they would have cancelled each other out.

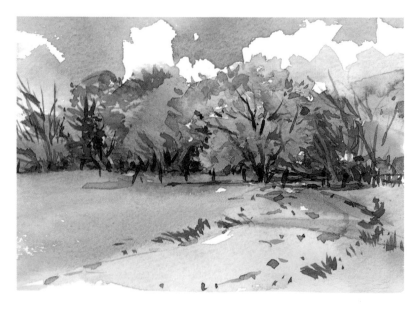

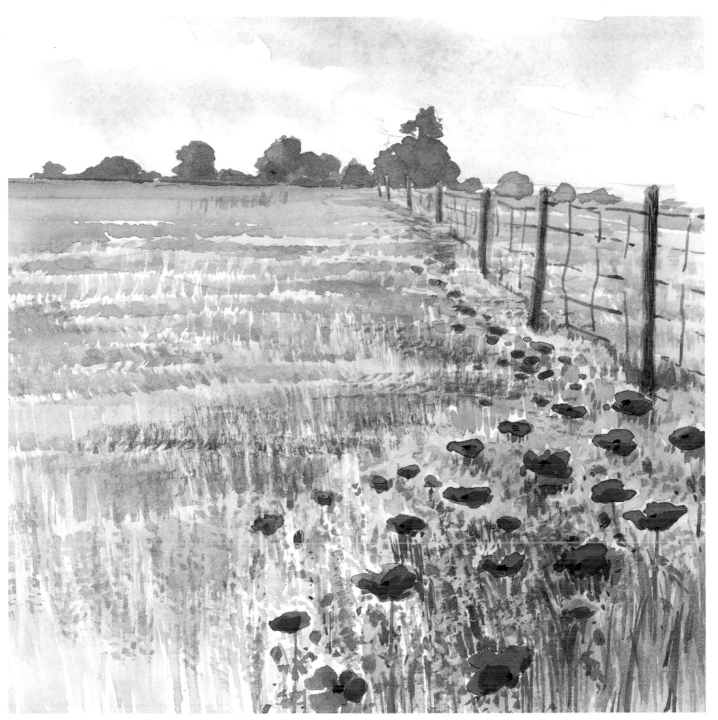

Poppy drift

Watercolour

Which watercolourist has not been tempted by – or attempted – a striking display of summer poppies? This example shows how I addressed a popular subject – choosing a slightly unusual square format and wet-into-wet technique, with green and red field colours dropped on a wet surface. I 'threaded' the dominant colour of my subject matter through the painting to unite the other elements. In this case, red – the dominant foreground colour – has been washed in weakly at the back of the field to create the drift of distant poppies, and it was also included in the green mixes. When dry, a square-ended brush was used to create surface texture, and the more intense foreground reds were added at this stage – perspective insists that round poppy petals should appear oval as they recede.

IMAGINATIVE OPTION

Flower paintings can seem 'samey' after a while, even if you use varied techniques. For an interesting composition, try arranging a vase of flowers or still life against a mirror and paint from an angle.

Landscape

Flooded field

Watercolour and ink line

This landscape was painted first as a watercolour. Colours were restricted to raw
sienna, burnt sienna and cobalt. The darkest tonal stage was reserved for the ink.
This was added using a fresh-picked twig, which also helped render the texture of
the path, grasses, fences and distance detail. Using the ink strongly on the upright
grasses helped provide a counterfoil for the horizontal nature of the composition. I
painted this standing up, which had a characteristic effect on brush and ink
marks. The arm makes a freer movement while standing, whereas a sitting
position promotes wrist-only movement. This can constrain painting marks. So to
free those brushmarks, stand up straight . . .

IMAGINATIVE OPTION

Should you wish to be much more adventurous, select one subject and tackle it in various different ways. For example, a landscape could be interpreted to emphasize a single aspect of the subject – like the sky, a building, animals within the landscape or even a major foreground feature. Try a different composition and technique for each painting in the series. I like doing this myself, because the final comparisons are fascinating.

IMAGINATIVE OPTION

Here is another variation on the 'series' approach that allows you to experiment with some different treatments, new techniques and media. Do an outline sketch (not too bold) of your chosen subject and make half a dozen photocopies on drawing paper. Then try and create six pictures that are as different as you can make them, all stemming from the identical 'starting point'. You might surprise yourself!

Patched barn

Watercolour and pencil

Parts of a building can be more striking than the whole. The mass of textures and interesting shapes on this old barn certainly attracted my attention. The building and lean-to structures had been patched many times with an assortment of iron sheeting. I chose a portrait format to make the most of the triangular peaked roof. Dark clouds gave the roof a silver cast, while the high window reflected what was left of the blue summer sky. I used watercolour, but the texture needed a lighter touch than the paintbrush, so the ridged roof and gate details were picked out with a 4B pencil.

Landscape

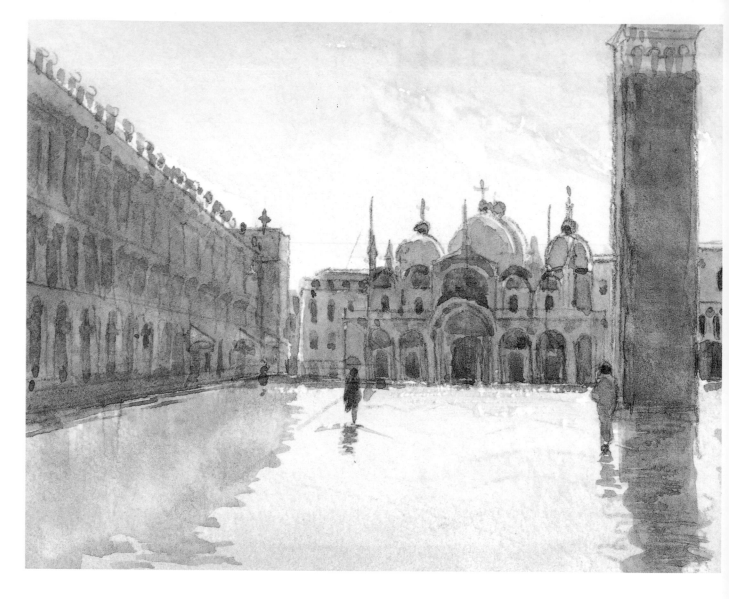

St Mark's, Venice

Watercolour

How many million times has this famous scene been painted? We will never know, but it made the challenge of creating something distinctive even more appealing. I rose at dawn and used contre jour (against the light) technique to create atmosphere. Early morning light touched the domes of San Marco, above the flooded square, giving a feeling of serenity before the arrival of massed tourists and the promise of a fine day to come. The lonely figures provided human interest yet added to the solitary mood. Although colouring on contre jour paintings appears limited to grey, there is much subtlety between warm and cool greys, and in the suggestion of colour just starting to appear. This technique can give a peaceful feel, and is well suited to capturing dawn and dusk scenes when the landscape can often be in its most seductive mood.

Gardenscape

Watercolour

Animal, vegetable or mineral? Some paintings cover several subject areas, and this is one of them. Luxuriant summer growth makes a good subject for lively brushwork. I used a large, soft man-made brush on Not surfaced paper. This was done standing up, allowing free arm movements that result in broader and more lively brushmarks. The inquisitive Jack Russell appeared fortuitously at the last moment to create foreground interest. Spattered watercolour was applied after the painting was finished to enhance vibrancy. This painting contains flowers, foliage, part of a building and an animal. So I tossed a coin and decided it must go in the landscape section!

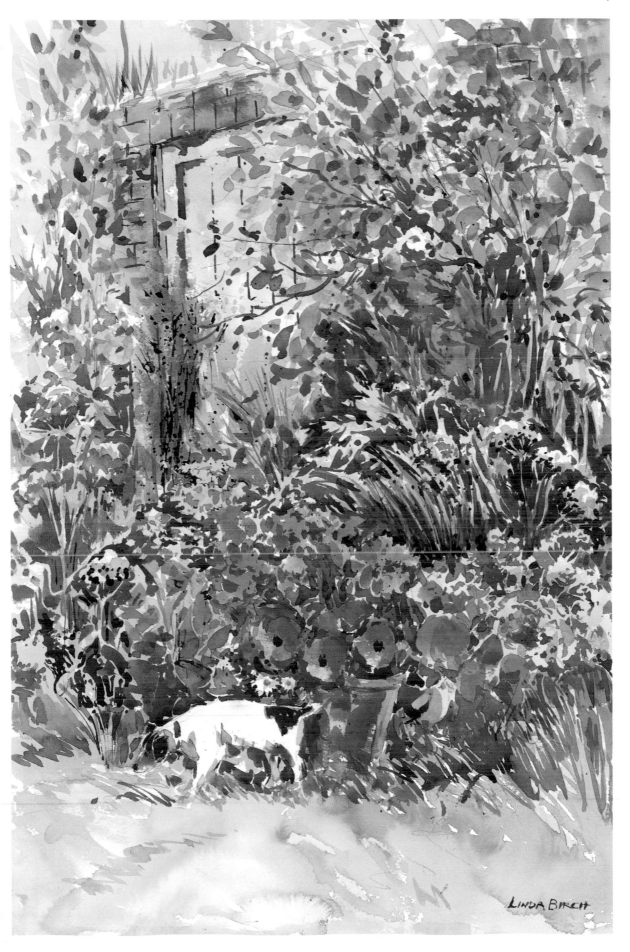

LINDA BIRCH

Landscape

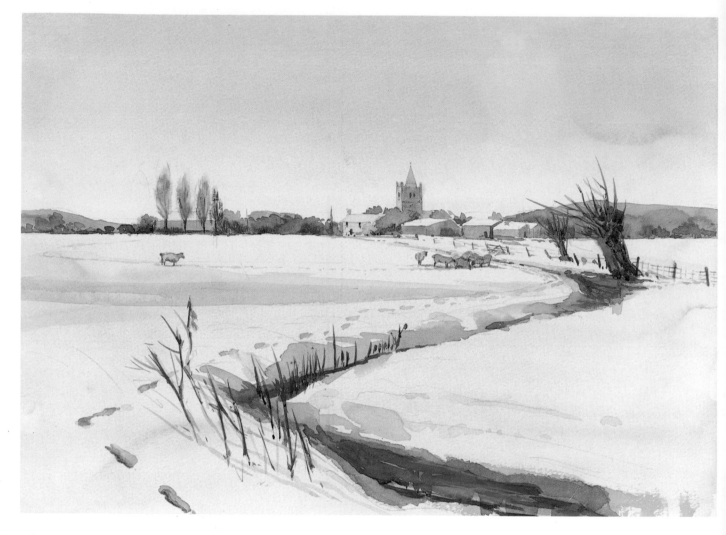

Sheep in winter

Watercolour glazes, watercolour

To communicate atmosphere, I decided to build up this painting in a series of glazes laid over the entire paper. Thin washes of yellow, red and blue were applied to the surface, with each glazed colour allowed to dry. This gives a luminous quality to the painting and perfectly captures the special light of this snow-bound winter landscape under a leaden sky. When dry, the painting was worked as a normal watercolour. The coloured glazes maintain interest in empty areas away from the focal interest of the frozen stream, feeding sheep and the cluster of distant buildings. The result was pleasing, which shows you do not have to 'over- paint' to achieve a strong atmospheric effect.

Approaching storm

Watercolour and ink

I'm always looking for subjects that offer striking contrasts in the knowledge that – providing I do my stuff – the resulting paintings will be dramatic. A stormy sky is an obvious possibility and if you can set a really strong tonal contrast against its looming presence, the overall effect will be lively. In this painting I drew the strong shapes with a pen and applied black ink with a brush to create the shadowed side of the barn. When dry, I completed the picture in watercolour. I particularly like the contrast of silvery roof against the blue-grey clouds behind.

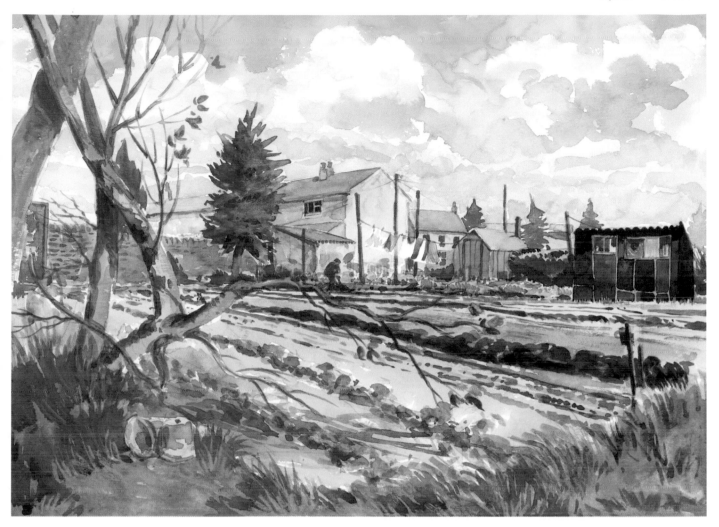

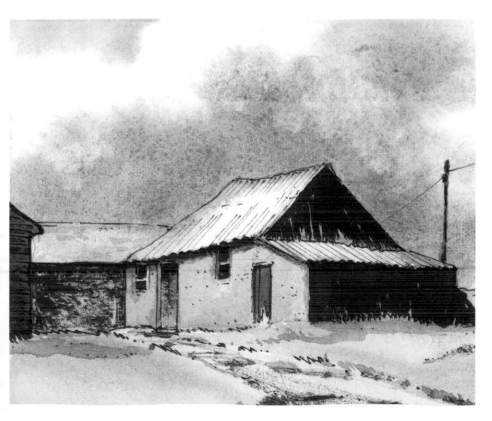

Spring digging

Watercolour and crayon

By contrast, this densely painted picture captures the mood of another season – the quality of a crisp spring morning when nature is awakening after the long winter. The breezy atmosphere is implied by washing blowing on the line and clouds scudding by. To achieve this effect, I painted the crisp clouds quickly and vigorously with a large brush on dry paper. The tree branch in the foreground leans into the picture, guiding the eye to the small but essential heart of this painting – the man digging beside animated washing on the clothes line. Touches of crayon were added, enhancing the texture of vibrant spring colours.

Landscape

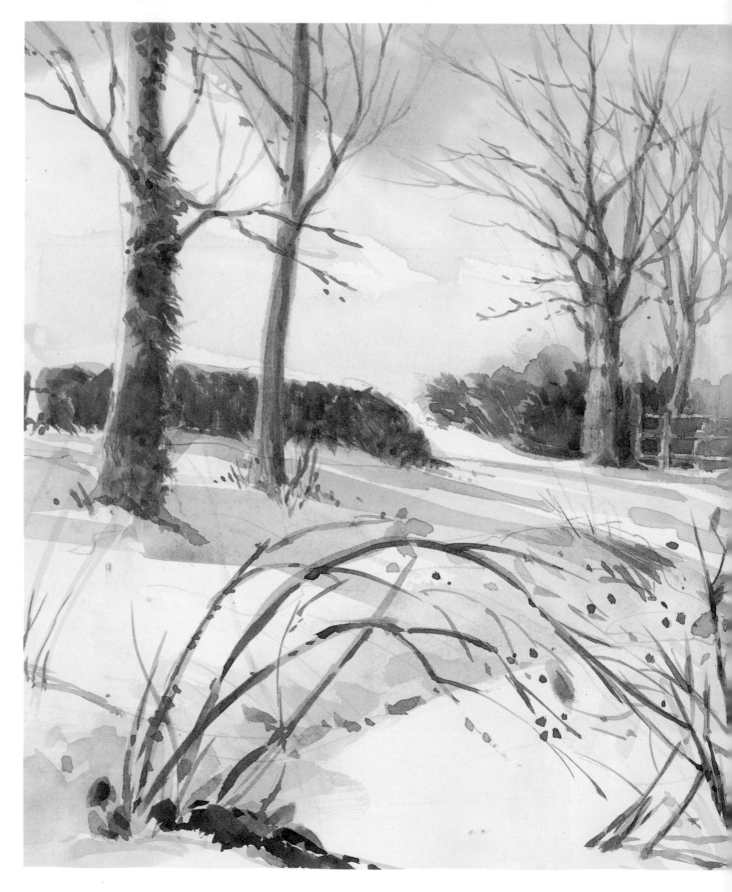

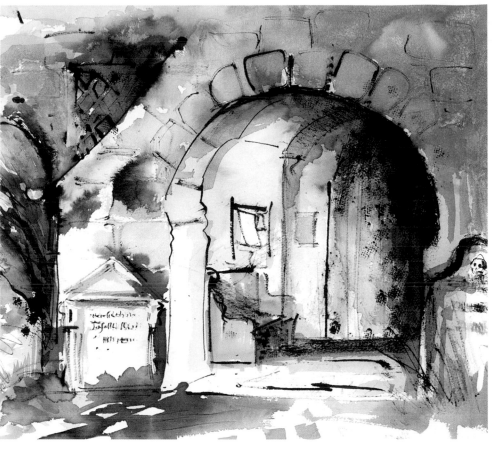

Stone porch

Ink and watercolour

This is a perfect example of seeking — and finding — a more dynamic approach. The ancient church porch and flanking gravestones might have been painted 'quietly' to exploit the timeless quality of the scene, but I felt the contrast of dynamic colour and ancient stonework offered real creative possibilities. This picture was first mapped out as a drawing, using a light pencil line. The pencil 'framework' was then freely interpreted in waterproof ink. To increase the expressive quality of the linework, and emphasize the rough-hewn texture of the stone, I used a twig to draw with. As the ink was drying, watercolour was added to complete an impactive mixed-media composition.

Rabbit run

Watercolour

I decided on stretched drawing paper for this winter scene, to give a smooth surface which is good for the fine detail I wanted. Paint doesn't 'flow' in quite the same way that it does on watercolour paper, resulting in crisper effects. I used transparent pigments — raw sienna, burnt sienna, Winsor blue, cobalt blue and a little cadmium red for the berries. This composition is a good example of how the eye can be 'led' around a painting to good effect. The eye notices 'danger signal' red first — so the berries point the way to the bolting rabbit, which in turn leads the eye up the roadway and on into the picture. Shadows on the snow make other links — for example, tree shadows lead to the brambles in the foreground. There's another compositional tip in this painting — the 'golden section' device. Using the short side of the paper as a measure, the rabbit was placed roughly where that measure fell on the long side. This can be done from the right or left edge and ensures that the subject will seem well positioned.

People

Though I have painted hundreds of formal and informal portraits and included thousands of human figures in landscapes, I must admit that people are not my favourite subject. Many artists have a preference (mine is animals!), and some specialize in their preferred subject to the exclusion of all else. There is no shame in that – if one subject area truly fascinates you, the advanced expertise built up by exclusive concentration can be totally satisfying. I see no point in wasting time struggling with subjects that don't appeal. If certain areas make you feel uncomfortable, simply ignore them. On the other hand, it may be that you do want to be an all-round watercolourist but find certain areas technically difficult. For example, I know from my students that many of them find the painting of people a little daunting, especially at first. If that's the case, strive to overcome the weakness. As always, practice is the key – but if you find you're getting stuck, try experimenting with different techniques, like atmospheric 'mood' compositions where the people are not required to have detailed features. This should help to build confidence and set you on the path to success.

Man on a donkey

Line and wash

I included this sketch from a Middle East journey to show that it is perfectly possible to make very satisfactory portraits, even if you are worried about your ability to record people realistically. Just be bold and don't worry too much about defining the features. This was painted after the ink lines were drawn with a twig, a wonderful drawing tool. Twigs can be sharpened, or not. The one used here was fairly blunt, yet made good marks. Twig-work gives a drawing freer character than steel nibs or styli. Waterproof ink is used (assuming you want to add colour afterwards). This is a good method for capturing any moving subject, because colour can be added later. Using pen (or twig!) and ink with watercolour brings another dimension to your work. For this study, I used the smooth hot-pressed watercolour paper that is ideally suited to line and wash work.

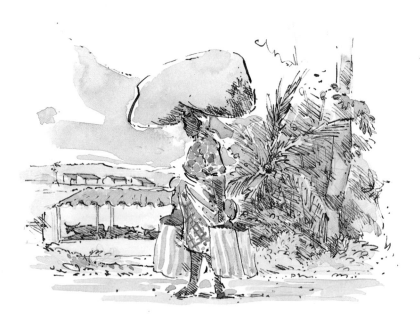

Burdened woman

Ink line and wash

An African picture reinforces the point that portraits do not have to be 'realistic'. I drew this swiftly with a nibbed pen and black ink, using hatched shadow to make the tones. When I got back to the hotel, light colour was washed over the top to complete the composition.

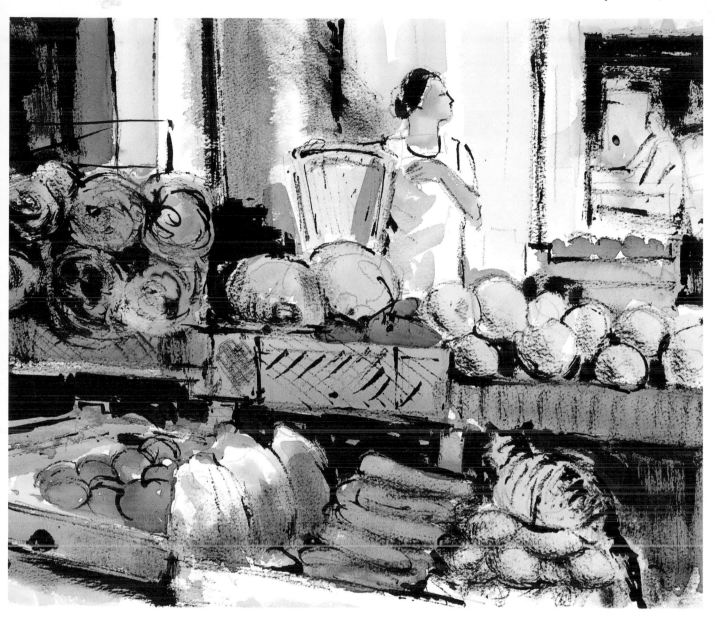

Market day

Brush and ink, watercolour

This market scene was painted fast using a soft, medium-sized watercolour brush dipped in waterproof black ink to draw the forms, then an old bristle brush rescued from household painting duties to lay textural colour. Used with watercolour, ink enhances the colour effect, helping the work to stay loose and open, automatically strengthening the end result. I recommend anyone who feels that their work lacks impact to experiment with this bold technique. Again, this style did not require the central figure to be painted realistically.

IMAGINATIVE OPTION

If you often see stimulating 'people' subjects, but lack the confidence to record them, try to improve observational skills and increase your drawing speed by attempting to draw fast-moving subjects from the TV screen. I find that sports programmes offer dynamic possibilities in this context, though soaps are good too.

People

Making music

Pen and ink, wash

A small sketchbook can be extremely useful in all sorts of situations and I carry one all the time. These musicians were 'recorded' during a concert (by me rather than a record company). I found a perfect opportunity to observe and draw, trying to capture freshness and spontaneity. A mechanical pen was used which – although only rendering one thickness of line because stylus pens do not flex – nevertheless was ideal for creating shape and tone. A light wash of colour was added later. This is one of my favourite techniques for capturing the 'essence' of people, without moving to formal portraiture.

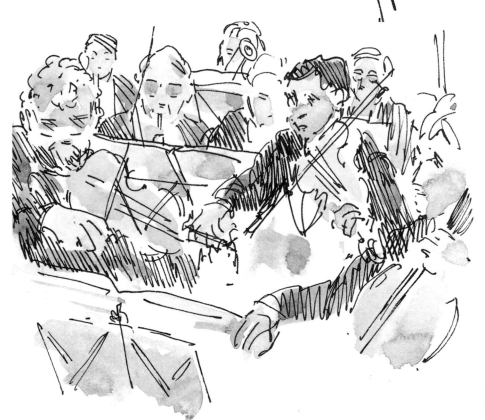

IMAGINATIVE OPTION

If you are troubled by painting detailed features, experiment with close-up portraits from different angles: full face, quarter profile, half profile, three-quarter profile and full profile – even a picture painted from behind! You may find that one angle suits you best. If so, practise that until you gain the confidence to try some more challenging portraits.

Worldbeater

Watercolour

To show that I'm not averse to more realistic treatment of people, this head of a boy is included. I painted him by laying patches of colour, some blended, some not. This technique makes the painting look bright and fresh. There's also a compositional point worth noting – always consider your subject and decide if you can compose a picture in a way that says something relevant. In this case, I decided to crop the head, have him staring out of the picture, and not to over-finish the portrait. This communicates his young age and character – not quite an adult, restless and impatient to charge on with life.

Old greybeard

Watercolour and glazes

I painted this splendid old gentleman on rough paper to create an appropriate sense of ruggedness. Strong lighting creates interesting effects in portraiture, so I lit the subject from the left and 'framed' him slightly off centre, tilting away from the light source. This made for a more intriguing study than the traditional 'portrait, with the full face in the centre of the composition. I used a combination of glazes and washes. The form was built up with raw sienna, raw umber, burnt sienna, cadmium red, French ultramarine and manganese blue – quite a palette for quite a character! Character is everything in portraits – contrast the weary experience in this face with the youthful optimism, energy and urgency expressed by the boy on the left.

People

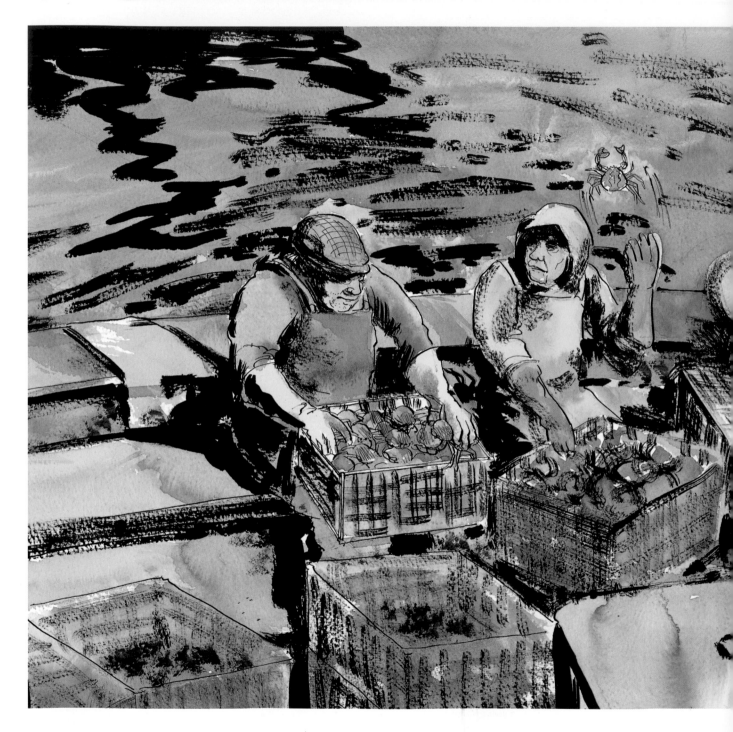

Crab pickers

Line and wash

I managed to contain my laughter and sketch these two men as they busily sorted crabs on their moored boat. The faces were slightly caricatured to express the humour of the moment. As they were talking and sorting, undersized crabs were casually thrown over their shoulders. I felt happy for the crabs that lived to be eaten another day and hoped the fishermen would not notice some which were trying to escape to freedom from the baskets! To give character and interest to this subject I both brushed and penned ink first, building the picture, before adding watercolour washes to bring colour to a scene I had already textured with the ink brush.

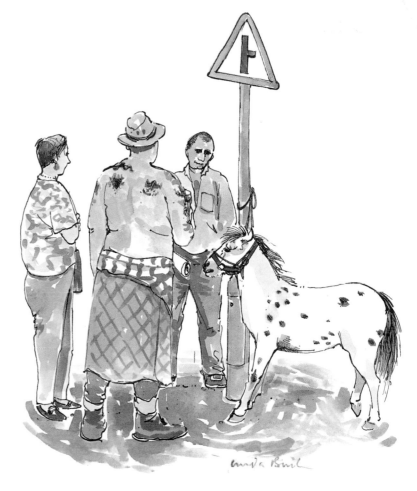

The bargain

Line and wash

In contrast to the heavily worked Crab pickers, this quick sketch shows what a useful medium linework can be for capturing a 'cameo'. I came across the haggling gypsies, whipped out my sketchbook and drew them before the bargain was struck. Sometimes this free approach can be more interesting than more detailed work. I might have left it at that, but when I got home I decided to add a quick watercolour wash. Together, both stages of this picture took less than five minutes to complete.

Roadmenders

Watercolour

My trusty sketchbook allowed me to make a swift soft pencil drawing of this group of road workers whose traffic control held me up. Before the red light changed, I recorded enough to build a watercolour over the top later. They were in the middle distance, so I initially painted them as soft grey silhouettes. When dry, I added colour. This approach 'bedded' the men into this small but atmospheric painting.

Flowers and still life

Of endless still life subjects, flowers must be the most popular – for they are both inanimate and vibrantly alive. Flower pictures do not have to be static floral displays in vases or pots. The watercolourist's aim should be to bring flowers to life. Various techniques can help you pursue that ambition, but there is one principle you should bear in mind from the start: it isn't necessary to paint every part of a flower in fine detail. Flower pictures can be extremely effective if you concentrate detail in the salient focal area of a bunch of flowers. The rest can be left a little looser and under-developed. Our eyes are attracted to bold shapes – often made by strong tonal contrasts or bright colour which we 'home in' on. We are aware of the rest of the flowers, but they are not actually in sharp focus. To find the focal area, close your eyes for a moment, then open and shut them rapidly. What you noticed in that brief glimpse will be your focal area, and that is where you should place the strongest detail. This simple but effective principle can be applied to any still-life subject.

Autumn glory

Collage, watercolour and inks

To exploit the vividness of some flowers I am often tempted to interpret them in something spectacular, like collage. This bright bunch inspired me to lay down a watercolour base, followed by torn pieces of tissue paper glued at random to cover the painting. When inks and watercolour were painted on, the wet paint crept under the tissue, causing it to wrinkle and create explosive colour effects. The surface was varnished when dry to provide stability.

Lemon tree

Watercolour

This picture is entitled Lemon tree, but what interested me most was the fruit itself. Painting the entire tree – even though it was laden with lemons – would have lost the focal point I wanted. So this simple watercolour became an exercise in composition. To increase the importance of the sharp yellow fruit as the painting's focused subject, I 'picked' two lemons nestling on the tree and treated them as a vignette shape. After washing in a yellow background, foliage was added around the lemon shapes until the fruit 'apperared'. When using this technique, start with the lightest colour, which disappears where stronger colours are added – in this case to make green leaves and dark background.

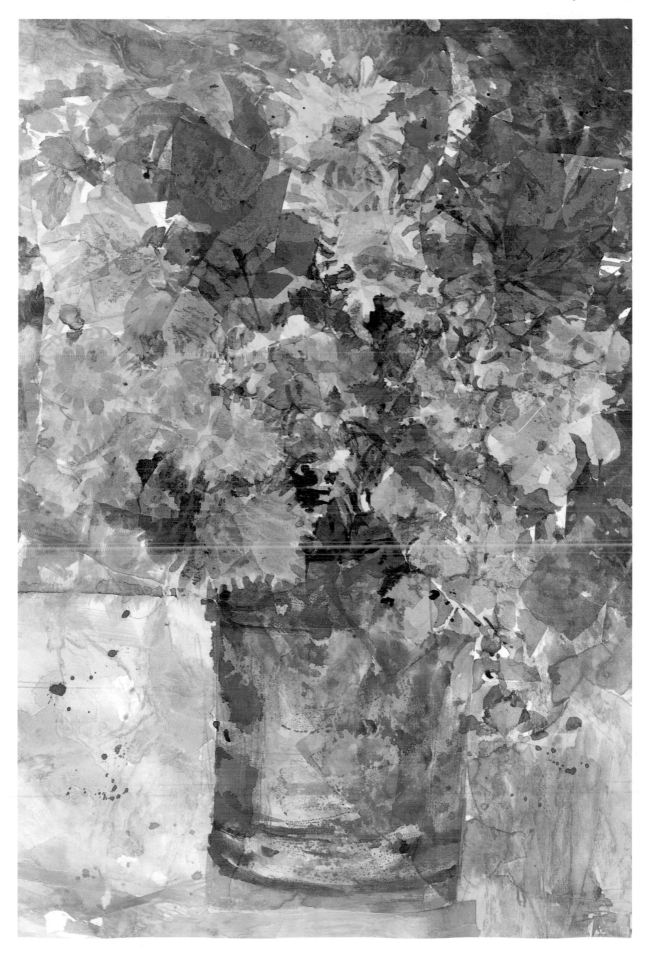

Flowers and still life

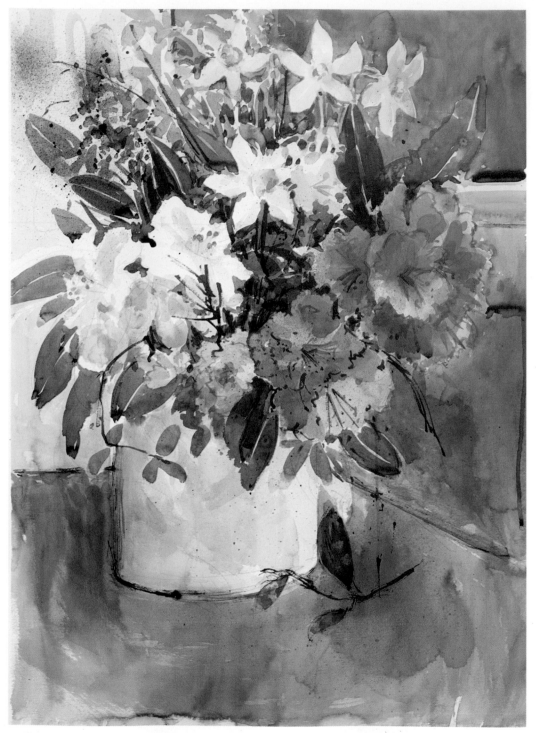

Rhododendrons

Watercolour

These spring flowers were painted on a (very) large piece of Not textured paper, which has complemented the free brushwork I achieved by standing up at my easel to paint this bold composition. The flowers were painted using the wet-into-wet method that is so effective for 'melting' colours together. A sturdy twig dipped in watercolour mixes was used to add lines and definition after the painting was dry.

Camellia I

Watercolour

I never tire of painting the same subject using a different approach. In Camellia I, I let the single stem stand alone as a bold detail study. The petals were built up from light to dark. Stamens were added using a little white added to the orange-yellow watercolour. Be sparing when adding white to make colour stand out in a dark area. The beauty of watercolour is its transparency, which is easily destroyed by over-application of white. I dropped clean water onto the leaf shapes with a brush — after they were painted green, but before they dried completely. This spread paint in a random pattern, creating light and texture on the leaves. I used hot-pressed paper, because the smooth surface assists smooth paint flow and crisp detailing.

Camellia II

Watercolour

Also painted on hot-pressed paper, Camellia II has a softer feel. I decided to emphasize the flower's fragility rather than its lush character. To achieve this, the flower was arranged in water as a reminder of its transient nature. The flower shape was painted a pale red. When dry, darker colour was added to produce a subtle arrangement of tones. The leaves were created in a similar manner. The rest was deliberately underpainted, with no background, to increase the importance of the tone and shape of the flower stem. And there you have them — two identical but rather different camellias, as intended.

Flowers and still life

Spring posy
Watercolour

We have all seen wonderfully detailed and accurate watercolours of flowers as botanical specimens, but that is a very specialized form of painting. Much as I admire the technical perfection of the results, it is not for me, as I feel these beautiful pictures are exquisite illustrations rather than 'art'. What I love about painting flowers is creating a sense of life and movement, mood and colour. This can be obtained by the use of lively brushwork. Here, although some of the primroses have been carefully painted to provide a focal point for the picture, the rest of the flowers and the background has been painted rather freely. I do not always use a background for flower pictures, but knew when I started that this 'loose' picture would benefit from a simple background in vignette form. It does not detract. On the contrary, it softens the picture and helps to create a sense of life by putting this jam- jar full of spring flowers into an undefined but solid context.

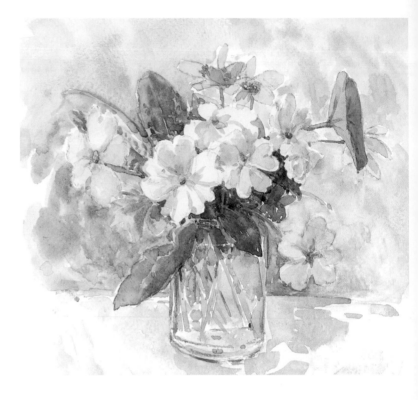

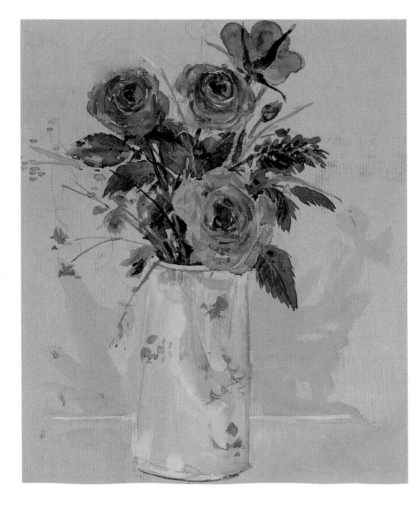

Rose on brown
Watercolour with gouache

If there is one word my students must be sick of hearing, it is 'experiment' – as a command. But they will go on hearing it. I believe the watercolourist should constantly be trying new things, because an adventurous spirit is a sure aid to development as an artist. These roses are painted in the style of flower painting that most appeals to me – quite loosely. I added texture to the blooms with a little gouache, underpainted the vase to create a focus on the roses and used an absolute minimum of background. So what is different? I chose a sand-coloured pastel paper, which has a 'brown paper' look. Before opting automatically for white papers, consider if a coloured ground might add visual impact.

Jugged marigolds
Watercolour

I love drama, and this bold picture shows why. It does not hurt that the marigolds are bright orange, but the real key is tonal contrast. Strong shadows on flowers create the effect of strong light and help them become three-dimensional. When using this technique, make shadows a little stronger than you think they should be, because the wet paint will dry to a lighter shade. I used medium Not paper and wet-into-wet method to render the background and shadows around the jug. Strong foliage and shadow between the blooms enables each one to stand out.

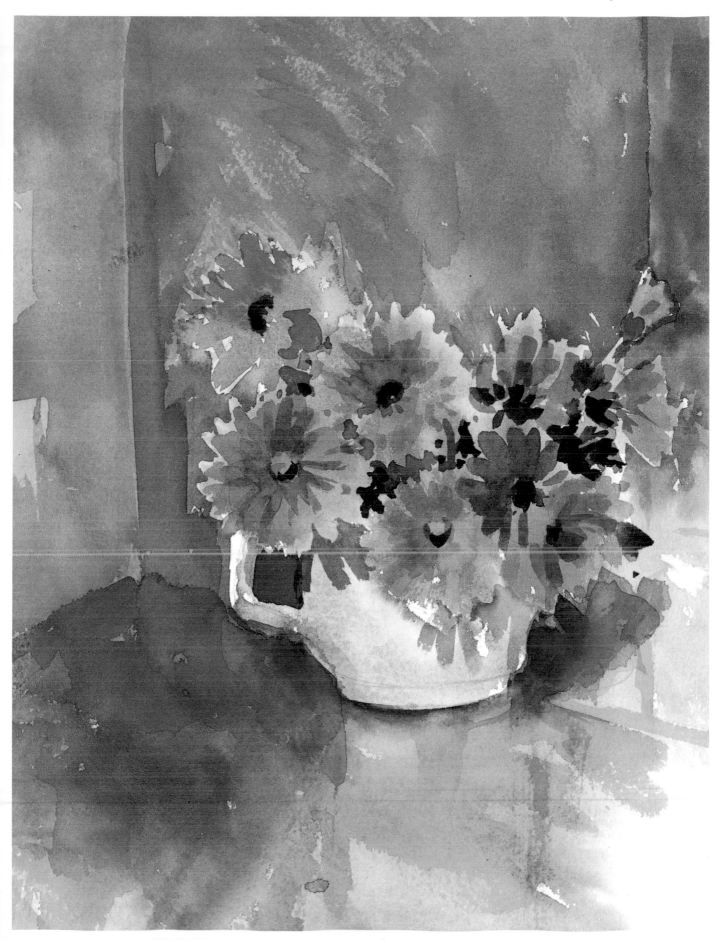

Flowers and still life

Fresh lemon

Watercolour

Never miss an opportunity. After painting Lemon tree (page 94), I could not resist picking this fruit, which made a deceptively simple but pleasingly subtle still life. I placed the lemon against the light to create strong and interesting shadows, which are the essence of this picture. The painting was made in strong sunlight, so I had to work fast to prevent the washes drying too soon. Using smooth paper, I washed in a semicircular background that set off the lemon's shape. Then the fruit was coloured in. Before it could dry, shadow was added. To soften the edges between shadow and light on the skin (important on any round object), a small damp brush was gently 'tickled' to blur the boundaries. Another good saying is 'waste not, want not'. The afternoon was hot, and after I completed this painting the unfortunate subject was sliced up and put to good use.

IMAGINATIVE OPTION

To avoid the familiar trap of a flower picture that painfully splits in half – flowers (top) and vase or container (bottom) – 'weld' the two 'disjointed' halves together by deliberately breaking a stem or spray of leaves so they fall across the vase to make a link between top and bottom. A petal or leaf lying on the ground by the vase has a similar effect. Or be greedy and use both. I do.

Fallen petal

Pastel and watercolour

Using a smooth hot-pressed paper, I started this still life of anemones as a watercolour. When the picture was dry, I added pastel over the top to bring the richness and contrasting colours of the flowers to life. The slightly textured paint surface provided a key that allowed the pastel to stick – though be warned that a pastel finish is fragile and easily damaged. With mixed media, classification can be problematical. If I had used only a small amount of pastel to enhance a watercolour, without destroying its integrity, I would have described this as 'watercolour with pastel'. In this case, however, the extensive use of pastel to create the feel I wanted led me to classify the picture unhesitatingly as 'pastel and watercolour'.

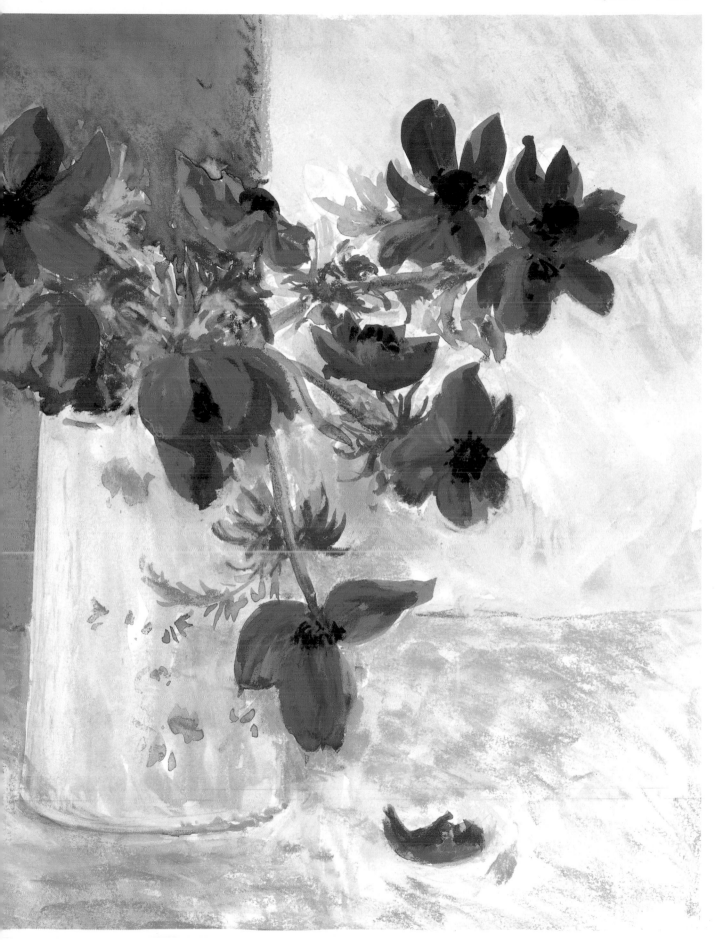

Flowers and still life

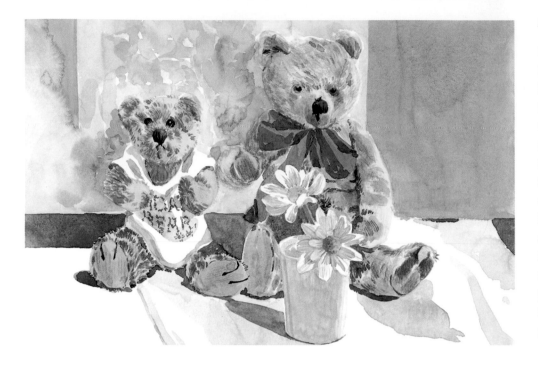

Teddy and son

Watercolour, coloured pencils

It always helps to paint subjects you like, because your positive feelings will give the picture a head start. These cheeky chappies were painted using a variety of painting methods. Dry brushwork was used for the fur and wet-into-wet for the background. The fur was built up first with a wash of light, clear azo yellow with a little raw sienna. Dry brushwork was added on top when dry, followed by texturing with coloured pencils. I had cut out the flowers, painting the fur around their 'masked' shape. They were painted last with shadows added to make them stand out boldly.

Ratatouille

Watercolour

These vegetables were painted very freely by starting with a loose pencil drawing that wasn't removed from the painting. Colour was used boldly, exaggerating tone and colour to make a vibrant collection of powerful shapes. The paints were allowed to run together, binding picture elements. Shadows also served as links from one shape to another.

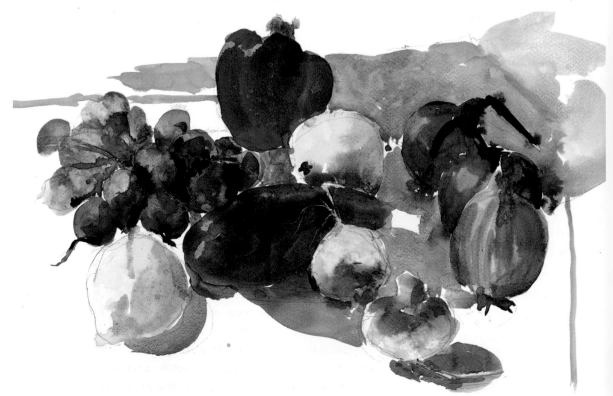

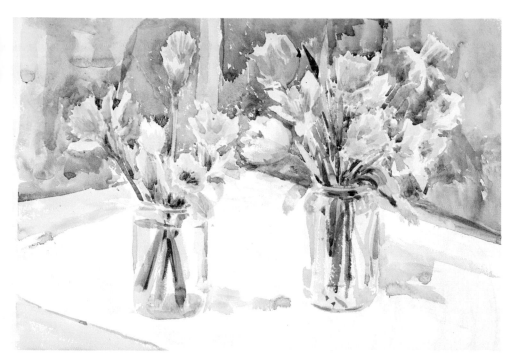

Summer spray

Watercolour

I wanted to achieve a loose, almost impressionistic feel with this composition of garden flowers 'carelessly' arranged in old jars, so I stood them in a corner to achieve an unusual backdrop. The flower shapes were cut out with masking fluid and the soft, swirling background painted wet-into-wet. When dry, the latex was removed and the flowers were loosely painted in muted colours that almost (but not quite) merged with the background for a wonderful patterned effect. Although not overpainted, the jars are an important element, because they hold centre stage and anchor the 'floating' flowers. They are set square to emphasize the 'angled' composition that adds tremendous energy to this picture, which I stressed by adding the simple washed 'horseshoe' effect.

IMAGINATIVE OPTION

Raid the house and collect a box of *objets trouvé* – things found that you might use as substitutes for your usual equipment of brushes and pens. These could be old household painting brushes, a pastry brush, shaving brush and textural objects such as sponges or scrap pieces of material. When you've filled an interesting box, try using the collection to paint a picture. You may find the end result is surprisingly effective.

Foxglove

Ink and watercolour

This foxglove stem has pronounced 'pattern' appeal, with strong curves and the diminishing size of the flower heads making an excellent subject. While not setting out to achieve the precise accuracy of a botanical illustration, I decided that this should be realistically portrayed, using pen and ink on the smooth hot-pressed paper that is ideal for the sort of precise penwork needed to render the stem accurately. When the ink was dry, I added watercolour, filling in the clean shapes to complete a simple but pleasing composition. And yes, I did pluck a bell and slide it on to my fingertip!

Animals

What can I say? This is the section that deals with my absolutely favourite subject – animals. Perhaps the sharp-eyed observer may already have guessed that fact, because it is surprising how often animals steal into my landscapes, beach scenes or pictures of people – though not, as a general rule, still life pictures. Even for those watercolourists who take pride in tackling a wide range of subject matter, it is no bad thing to have one area they find especially stimulating. That special interest can strike the spark needed to turn technically competent work into something more – paintings with real verve and spirit. It can also encourage experimentation, as the artist will strive to capture the quality that appeals so strongly.

Talking heads

Ink and watercolour

These character studies are ink line drawings over pencil, enhanced with colour. I used a twig for the bold ink work, with a mechanical pen used for fine detail. Fingerprints were used on some of the coats. Colour was added, using dry brush to give more texture. It is essential to strike the right balance between line and colour. The colours must not be stronger than the line or the whole effect is lost. Line with watercolour is ideal for new painters who may be rather timid when using colour – and little pictures like these make the perfect gift for friends whose beloved pet you can immortalize – though do not make any assumptions. I don't actually know anyone who has either a koala or a chimp.

My Guy

Watercolour, coloured pencil

Who could resist this fellow? I painted him in watercolour, using cobalt as an underwash to create the lighter fur and the shadow on the white hairs. A mix of Payne's grey and cobalt was applied when the first wash was dry. Burnt umber was used for brown areas of the coat. Cadmium yellow captured the eyes perfectly, with raw sienna used for the upper eye shadow. When dry, coloured pencils were used to pick out light hairs and whiskers, and also to make a dense texture to the coat. Coloured pencils work well with watercolour, helping to create or restore texture that sometimes gets lost when painting. Keep them sharp for best results. I used smooth hot-pressed paper, which is ideal for work that calls for dense detailing. Because the black-and-white cat made such a strong and distinctive shape, I kept the background to a minimum, merely suggesting the line of the floor behind.

IMAGINATIVE OPTION

Don't be ashamed of using colour photographs to capture 'will not sit still' animals. When using the camera, attempt to compose each shot as though it were a painting, with the 'sitter' in an interesting pose. A watercolour can be worked up at your leisure. To have some fun, take several photographs and put the same animal – say a playful kitten – several times into one amusing picture. This works with children, too.

Animals

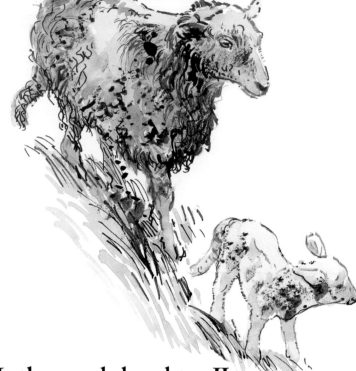

Mother and daughter I
Ink and wash

Who can resist a newborn lamb? Not me! I used watered ink to pen soft outlines of the two animals. To create the fleeces, a sponge dipped in ink was used on parts of the forms. Fingers dipped in ink were also used on the bodies and the ewe's shaggy coat was strengthened with additional pen work. When dry. I added watercolour wash to provide colour and halftone between dark and light areas – and to emphasize the steepness of the hillside where I spotted this sure-footed pair.

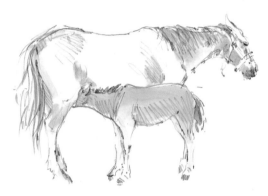

Mother and daughter II
Pencil and wash

This sketch of a Welsh mare and her foal was drawn quickly with a soft 4B pencil – they would not stand still. I lifted the sketch into a study by adding a small amount of colour. A study can be just that – a reference for all or part of a subsequent painting, and more satisfying than the use of photography for the purpose. Sometimes, however, a study can be as important as a finished painting, because of its freshness and immediacy. That spontaneous quality can be lost somewhere between study and fully painted picture.

Flock by night
Pencil and wash

Apart from their interest as primary subjects, animals can make an intrinsic contribution to more general compositions. As dusk falls, this shepherd in the Middle East guards his flock in the late evening sun as they await nightfall. This was painted by dropping in wet colours on top of each other, starting with the lightest (raw sienna) and finishing with the darkest (French ultramarine).The outlines of the sheep against the light were kept clear of colour once the raw sienna had been laid down, to achieve the 'halo' effect that often characterizes atmospheric contre jour paintings.

Lord of the skies

Crayon and watercolour

Every feather of this magnificent eagle deserved to be shown, so I used hot-pressed paper which has the smooth surface conducive to crayon and fine detail work. The background and bird were first painted in watercolour, keeping the shadows a little lighter than usual. The plunging eagle was then developed using crayons, working from light to dark. The background was left as a watercolour. Crayons are a valuable addition to your equipment. They can produce superbly textured results like this in their own right, add detail and texture on top of any watercolour, or even provide 'first aid' when retouching is needed to rescue a picture.

Animals

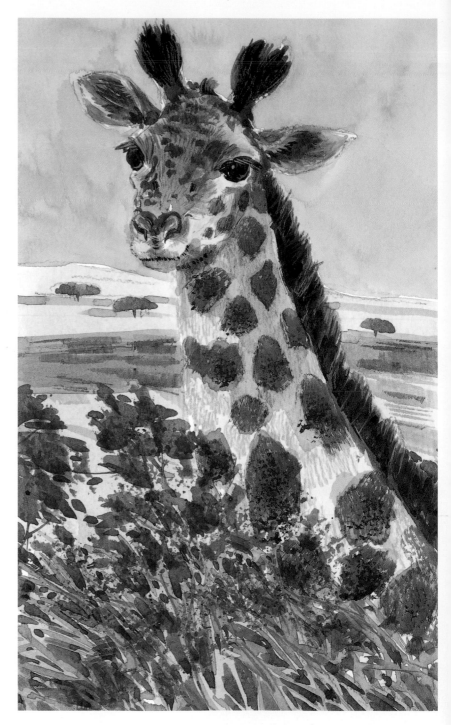

Tall story

Watercolour

In the case of large animals, serious consideration should be given to concentrating on an interesting portion in the interests of a manageable composition – usually the head. They do not come much bigger than this giraffe, so that is what I did. I painted on a Not textured paper using mixes of raw sienna, burnt sienna and French ultramarine. The distinctive markings were made by employing dry brush technique. Tangled treetops were cut out with masking fluid before laying the first wash of raw sienna. When dry, the mask was removed and darker colours overpainted to make gaps and define twigs. A sponge and hessian rag were used to strengthen foreground texture. This picture shows how you can exaggerate natural colours somewhat, in order to endow your subject with a commanding presence.

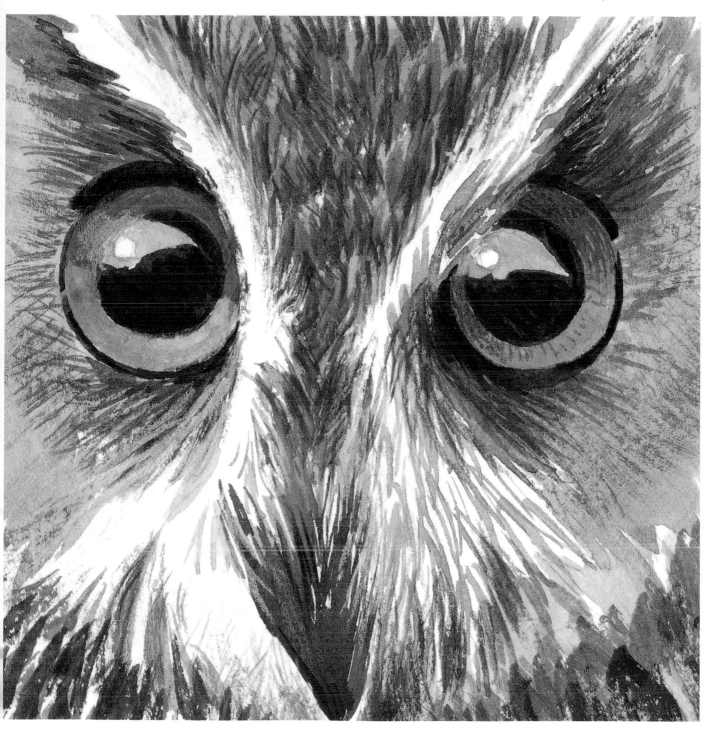

Owl eyes

Watercolour

There are times when painting a selected part of a form can say more about the subject than a complete rendition – as with my choice of the owl's most characteristic feature, those huge staring eyes. Eyes are the most important part of any face, human or animal, and should be painted with utmost care to convey a feeling of life – note the reflected moon visible in this close-up, reminding us that the owl is a creature of the night. I used a Not surfaced watercolour paper, with a palette of five strong colours – burnt sienna, burnt and raw umber, orange and cobalt, and feel the result effectively communicates this imposing bird's character. Mice are recommended to start trembling now.

Animals

Baby seal
Watercolour

Using coloured paper as a ground for watercolour painting can inject new life into your work. Pastel paper is sold in a range of colours, allowing you to select an appropriate shade for the composition you have in mind. For this grey seal pup, I imaginatively opted for . . . grey! The working method was unusual. Dark colours were applied first as normal transparent washes. Colour was built up using white mixed with the colours to add opacity, masking darker background washes to make the image more visible. Finally, I used a thin brush to add white on its own to create the pup's light fur.

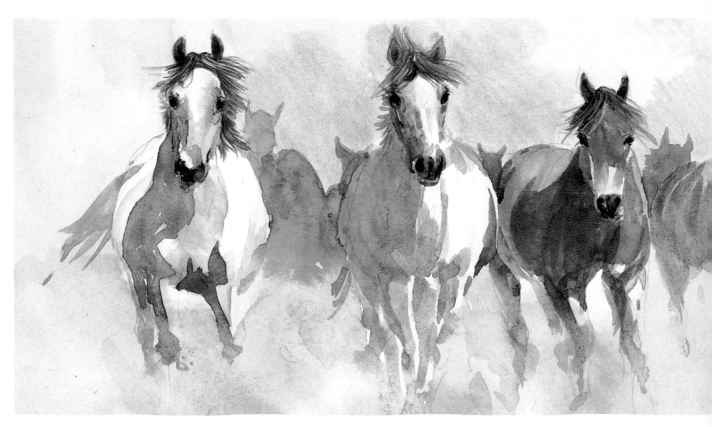

Stampede

Watercolour

I chose the wet-into-wet method for the lower half of this action painting, to create a dynamic sense of flying hooves and rapid movement. The upper bodies of the galloping horses were marked out in soft pencil and painted on a dry surface down to the knee joints. Before the paint dried, the remainder of the paper was wetted. I then dropped in cobalt and raw sienna and allowed them to spread, 'dissolving' the legs and giving the impression of billowing dust. When the subject is moving fast, the 'speed blur' can be communicated effectively by using wet-into-wet, if necessary combined with another watercolour technique, as here.

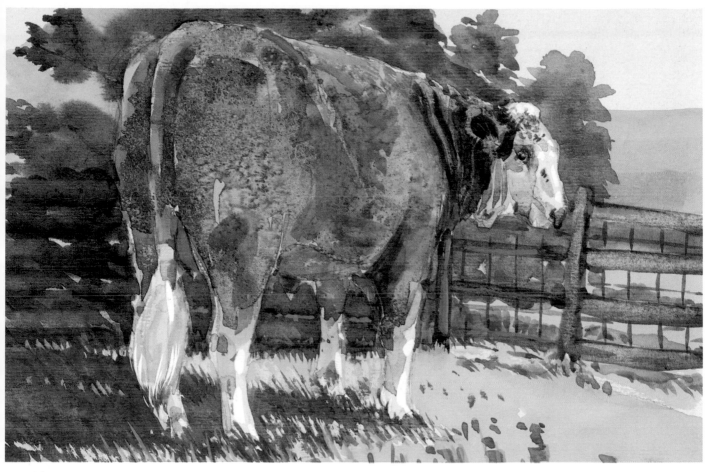

Belligerent bull

Watercolour, gouache

For this study I selected a grey pastel paper. Tinted paper has the positive effect of unifying colour and making a composition 'hang together'. The belligerent beast was drawn out in pencil – from behind, and a safe distance, though he still spotted me! This wasn't just a matter of prudent self-preservation, because I thought the slightly unusual angle would add interest. He was drawn out in pencil and watercolour added – raw and burnt sienna for the coat. Salt was sprinkled on while wet to add texture. When dry, a little gouache was added to give detail to the grasses.

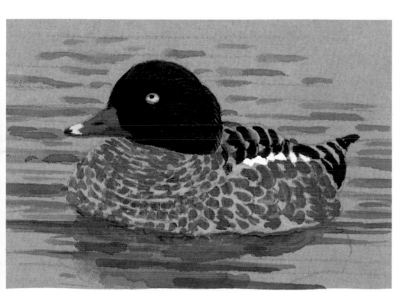

Black-headed duck

Watercolour, gouache, coloured pencil

This is another picture painted on tinted pastel paper, which I felt would enhance the strongly contrasting black-and-white appeal of the duck. The only paints used were Payne's grey and white gouache. When dry, coloured pencil added definition to the head. Payne's grey is a splendid colour for achieving monochromatic effect, but should be used with caution in full-colour painting. It can dominate, resulting in lifeless colour mixes.

Animals

Farmyard chickens

Watercolour

I liked the way these chickens were standing in the sun, framed by the open stable door and indistinctly reflected in the puddle. The dark background was painted using strong colour washes of raw umber, rose and French ultramartine. I masked out the window with tape, which was removed after the washes dried. Note how I applied the 'odd numbers' rule here – imagine the 'safe' composition without the third bird that perches on the water trough and you will see this is one rule rule that has a lot to recommend it.

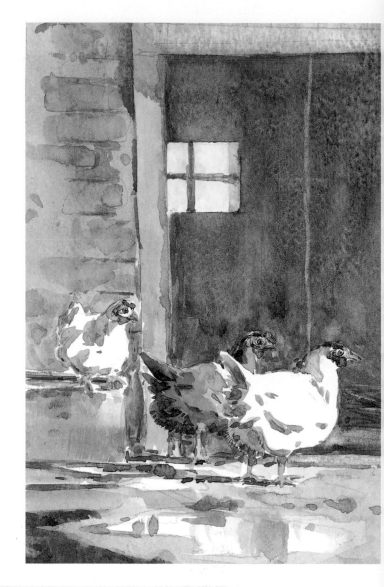

French beef

Watercolour and gouache

These sturdy cattle were painted in France, at one of those markets where everyone from the surrounding countryside seems to come to town for the day. I could have concentrated on the bustling wider picture, but it is sometimes most effective to chose a focused main subject. I was drawn to this composition by the whiteness of the cows, set against the soft blues and greys around them. I used hot-pressed paper for its smooth texture and started the painting as a watercolour, with gouache added at a later stage to give substance.

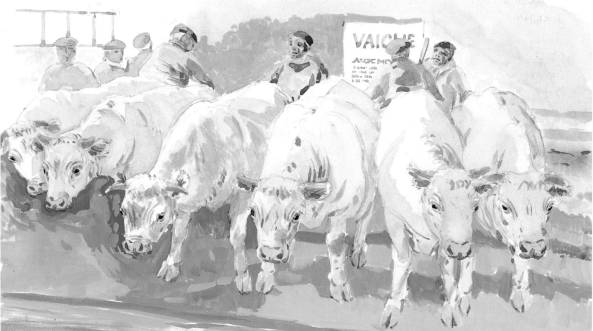

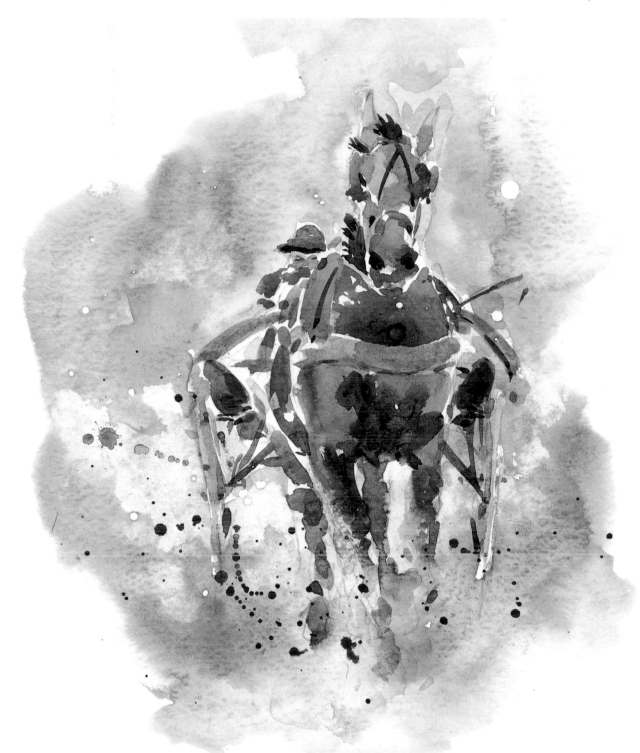

Flying hooves

Watercolour

Here is the way to communicate all the dynamism of a dramatic 'action shot'. To create the sensation of speed, I have used several techniques. First, the horse's feet disappear in a blur of movement, rendered by the wet-into-wet method. Second, areas of paint have deliberately been left disjointed by allowing areas of white to remain – the opposite of the more usual objective of 'knitting' a painting together. Third, the spattering of paint was used to suggest rapid movement. One of the magical aspects of watercolour painting is that the eye can be fooled – if you make the right suggestions, the eye will complete the picture and effectively save you from doing the job on paper. This process is known as 'completion', and this picture is a perfect example of the way in which solid form can emerge from suggestive shapes, colours and tones.

Animals

Horns of plenty
Watercolour

This disdainful ram was painted on rough-toothed paper to bring out the quality of his shaggy coat and rough horns – a good example of the way in which paper choice can contribute significantly to the feel of a painting. The ram's wool was built up using successive washes of raw sienna, burnt sienna and French ultramarine. Using mixes of burnt sienna and French ultramarine, a dry brush technique was applied to finish the textured coat. I paid particular attention to the 'life-giving' eyes.

IMAGINATIVE OPTION

Instead of launching into a big animal portrait, do a series of thumbnail sketches to explore different compositions. You may be surprised by the way in which the animal's character can appear to change.

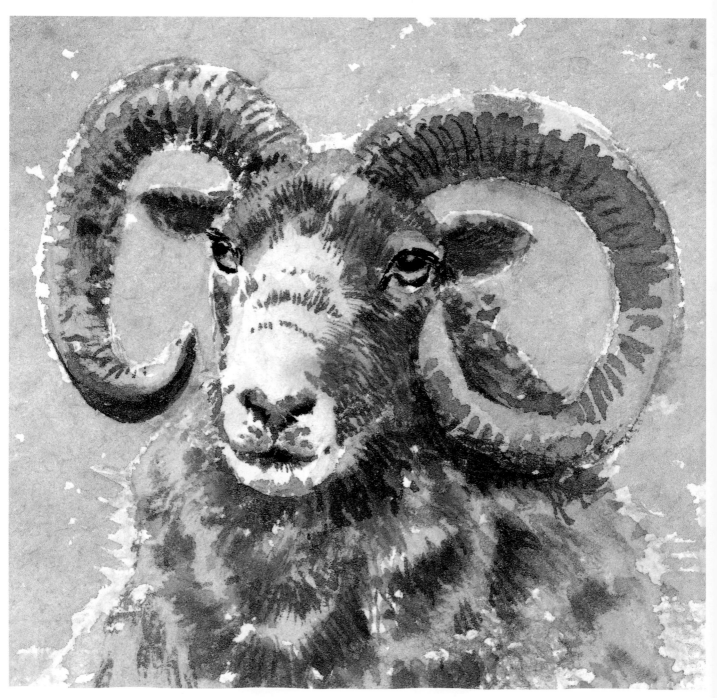

Lion king

Watercolour and ink

I also used rough paper for my friend Leo, starting him off as a watercolour. His fur was painted using washes of raw sienna, dilute azo yellow and burnt sienna. I allowed the colour to dry, then switched to black Indian ink to provide striking contrast. The mane was sponged in and fingerprint technique used for the face texture. Finally, I used a twig to give the 'electric' effect that makes the animal's coat stand out from the background – and creates the distinct impression that the lord of the jungle is about to spring. Don't worry, I survived – this power-packed portrait was painted from a photograph.

Water

It's a happy coincidence that one vital ingredient of watercolour painting – the water – also happens to make a superb subject for the medium. I believe the skilled watercolourist is ideally placed to communicate the spirit of water in its many moods – calm and still, restless, moving, sparkling, always changing, catching reflections, falling from the sky, surging against the shore. I could go on – endlessly! Even a photograph, however spectacular the composition, can only 'freeze' water for an instant in time, while a watercolour painting is able to offer movement and life. By definition, the wet-into-wet method is an indispensable technique for creating evocative water paintings, capitalizing on water's characteristic ability to move and mix. If I have a problem with making water paintings, it's that I am inclined to spend hours watching the water in idle fascination, rather than reaching for the brushes!

On the beach

Watercolour

This picture was painted on a Not paper to give surface texture. Sky, land and sea were created first, using a palette of raw sienna, cadmium yellow and cobalt. I then brought life to the picture by adding the figures that also balance the otherwise horizontal feel of this painting. The people in the background were simply painted over the pale colour, while the foreground figure was masked and lifted out. The eye is led into the picture by footsteps in the sand and the running dog. To create sparkle on the water a sharp craft knife was dragged across selected areas, literally raising the surface of the paper to give the waves movement and a lively three-dimensional appearance.

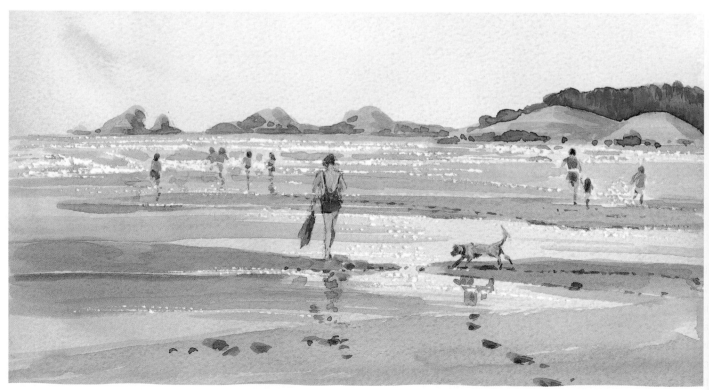

Reflective rock

Watercolour

This rocky outcrop in the water just off the beach appealed to me because it was reflected in the sea. I used the wet-into-wet method, floating the soft orange colour into the sea while still wet. A small breaker approaching the shore balances the large rock. For added effect, I scratched out some of the foam spray with a sharp-pointed craft knife when the painting was dry. Complementary colour is important in this painting, with the orange-red rock and blue-green sea creating a counterpointing dynamism.

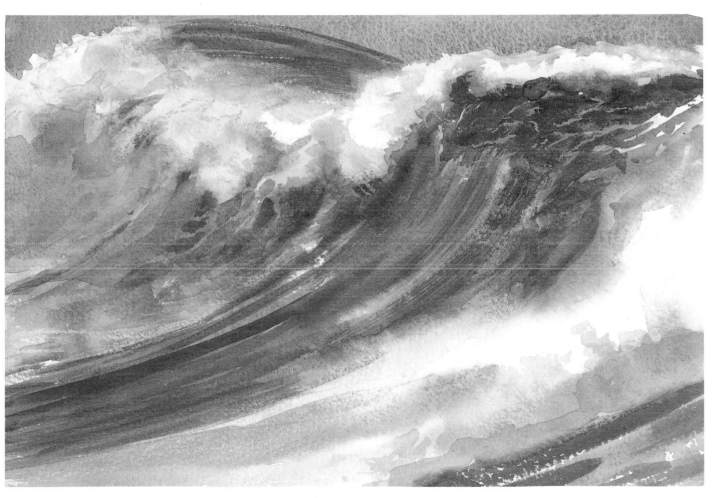

The big break

Watercolour and crayon

This huge wave was drawn as a collapsing curl shape, which was first indicated lightly with a pencil. Wet-into-wet method goes naturally with seascapes and I used it here. The entire picture area was flooded with water and then a mix of olive green and cobalt was brushed on to indicate the shadow areas under the wave and also the bulk of water appearing in the right-hand top corner. The crests were left clear – with encroaching wash dabbed off with cotton wool – before pale cobalt was added into the shadow areas of the foam. This picture dramatically illustrates the dynamic potential of water.

Water

IMAGINATIVE OPTION

If your water paintings lack sparkle, try using a knife to create tiny highlights on the water's surface. Make sure the knife is sharp and use the tip, dragging across the water in a straight line. For a 'white water' effect you can lift the paper surface to give a 3D look. Once you've used these techniques, don't attempt to paint on top – the surface of the paper is broken, so paint will sink into your highlighting and spoil the picture.

Lifting bridge at Delft

Line and wash

If you are asked to name two things you can't escape in Holland, think water and bicycles. I used technical pens to draw this typical Dutch scene. These have a stylus rather than a nib, making them ideal for precise and detailed work – their primary function is, after all, the drawing of plans. After finishing the ink drawing, I washed in the 'hard' landscape and cyclists, making sure the buildings and church in the background were pale to give perspective and depth. Then I painted a conventional watercolour – the rippled canal in the foreground. Note how the broken reflections become larger and thicker as they approach the viewer.

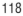

Frozen pond

Watercolour

The twigs and branches of this frozen pond near my home made an almost abstract composition against drifting snow and the low winter sunlight that was falling on the ice and field beyond. It is always worth keeping an eye out for interesting shapes that you can exploit by creating a painting that contains unusual patterns. A square-ended brush was used to increase the effect of stark branches, with fine detail picked out with a twig I picked on the spot. Straight lines balance the soft, rounded snow mounds – and it's interesting to note that the reflective snow to some extent counteracted the impact of contre jour lighting that would normally have muted the foreground definition.

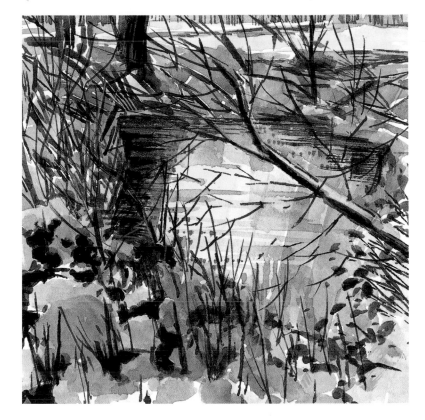

Hidden Venice

Watercolour and coloured ink glazes

The bottom of this wall and the disturbance caused by a passing boat on this minor Venetian canal created interesting textures. I studied the scene for some time before deciding on my method – a watercolour base with an overlaid glaze of coloured inks (yellow and olive), which increased the feeling of damp and decay. The contrast between the smooth, reflective water and the wall's crumbling plasterwork over brick added to the interest. A twig dipped in black ink picked out detail on the wall.

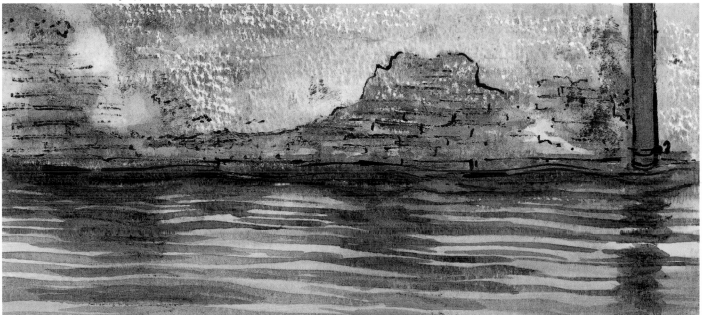

Water

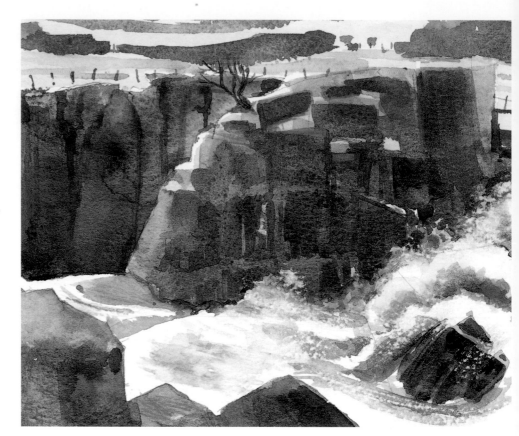

High force
Watercolour

I'm always looking for – and tend to be inspired by – unusual and dramatic compositions like the elemental force of white water that had carved the river channel deep into the rock. To enhance the drama of the rapids, the rocks were painted in rich, dark shades against pale water. The spray was created with a knife and the texture further roughened with a scrap of sandpaper.

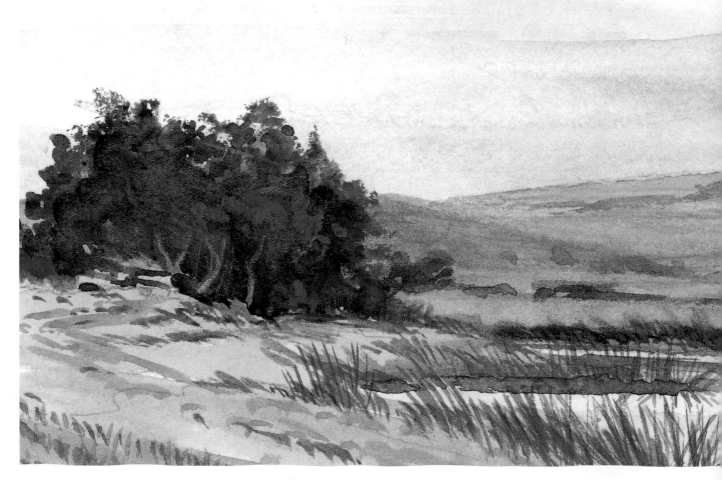

Tumbling brook
Watercolour

Always ask yourself if a particular picture shape will help to 'make' a composition. This was one of those landscapes ideally suited to portrait format. The 'containing' limestone rocks were painted, leaving gaps for the water. This was added as a series of pale blue-grey tones for the shadows, leaving the paper unpainted for highlights that suggest fast-flowing water.

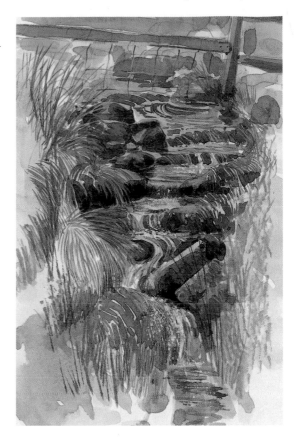

Mountain tarn

Watercolour

Many cameras allow you to choose different frame shapes, including a shallow but wide option that creates a very effective 'panoramic' feel. It is a choice the watercolourist can also use to advantage. The sun was setting and trout were rising when I came upon this mountain tarn. Although the bright water initially attracted my eye – and was the subject I wanted to paint – I quickly decided it would be best represented within the broad landscape it occupied so serenely. I chose this elongated shape to capture the rolling setting and laid a glaze of raw sienna over the whole picture. While wet, I streaked in the sky with alizarin and cobalt. The land was painted mainly in raw sienna, from which greens were mixed. Foreground trees were painted in raw umber, burnt umber and viridian green, with lighter foliage on top sponged in using azo yellow, raw sienna and cobalt. Ironically, my main preoccupation – the water – was largely represented by the pale background glaze that worked as an effective highlight.

Water

Bubbles

Watercolour

I am always on the lookout for something unusual and challenging to paint. That is the sort of positive thinking that can only improve my work (and yours)! A photograph of a swimmer trailing bubbles really had me going, suggesting a variety of techniques that might be used to achieve the right effect. I decided on wet-into-wet to create the white water, while larger bubbles were made with masking fluid and 'bedded in' at the end with a soft-blue wash. After the figure and water were completed, the smaller bubbles were lifted out with the point of a sharp craft knife. And teacher's verdict? Very good, but must keep trying new things.

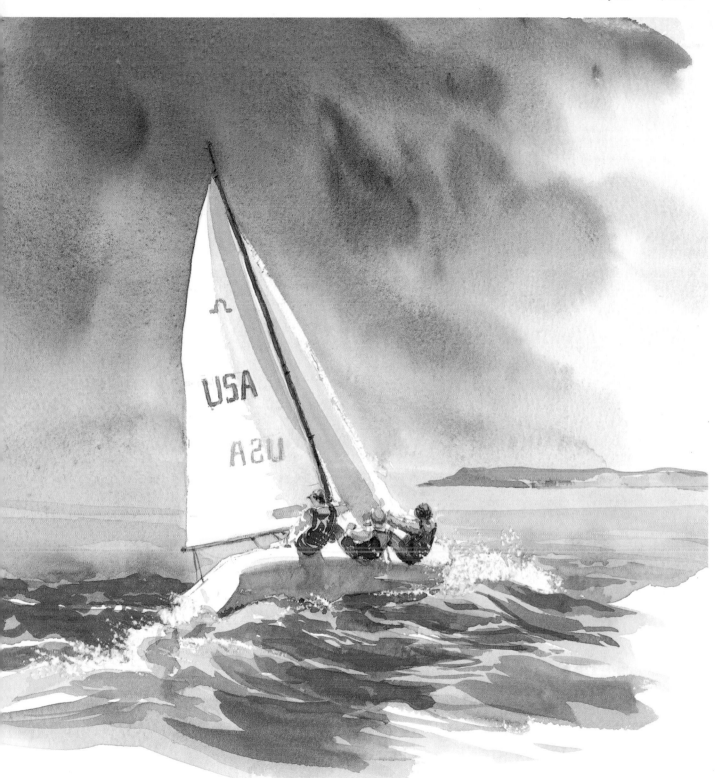

Racing the wind

Watercolour

The whole rationale of this painting is dynamic motion, as the sailors strive to squeeze the last ounce of speed out of their heeling yacht. I outlined the focal point of the picture – the boat itself – in soft pencil, then washed in the threatening sky, background sea and distant shoreline. I then built up the boat and its crew, knowing the steep angle would emphasize movement and suggest the force of powerful wind. Seething water in the foreground added energy, while the dramatic effect was completed by boiling white water at the bow and stern. These features were lifted with the tool no watercolourist who paints water should ever be without – the sharp-pointed craft knife.

Water

Rock of ages

Watercolour

Like shadows, reflections can be an integral part of a composition – and quite possibly the reason a particular scene appeals in the first place. Background sky colour was painted over the whole picture first, reversing it in the water area. When dry, I painted the rock face over the top and its paler reflection in the water (light objects reflect darker in water, while dark objects reflect lighter, as here). Trees on the shore were painted as dark shapes in the shadow of the rock and a light edge picked out to show the water level. After this dried, clouds were painted in. I kept the bases light, using raw sienna, and drifted dark blue-grey in while still damp to complete the clouds. This is an interesting example of a landscape-style picture that works well in portrait format.

IMAGINATIVE OPTION

If you feel like attempting something different, switch to the roughest watercolour paper you can obtain. You will soon find that painting on very rough paper creates some interesting effects – where the loaded brush 'skips' across the bumps a lively, speckled-white finish is created. This is a good way of conveying the sense of movement and life – in animals, water, a wind-blown subject . . . even lively flower paintings.

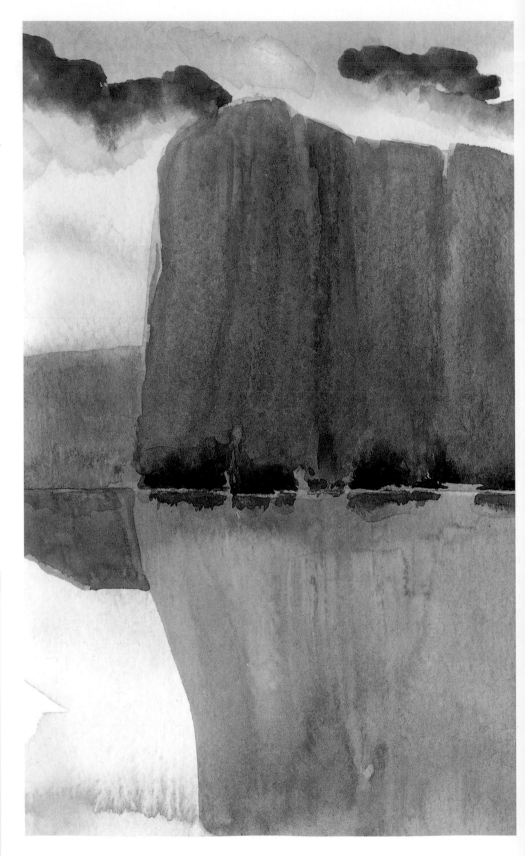

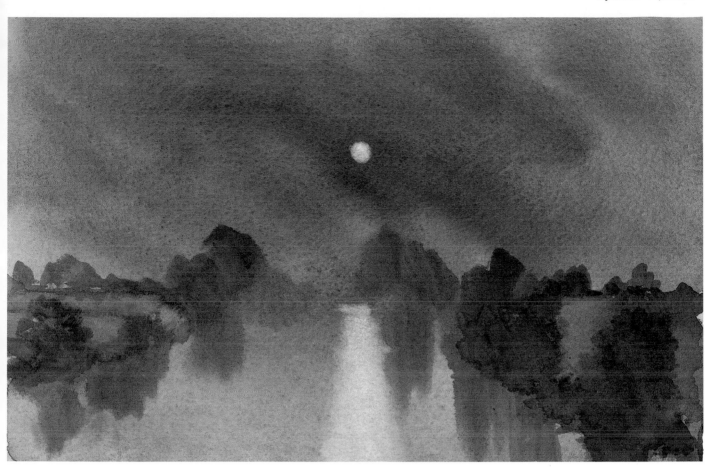

Moonlight

Watercolour

There is something compelling about the moon reflected in water. I certainly find moonlight has a very special quality and I like painting on moonlit nights. For this steely scene, the dark sky was laid in first, followed by water of a lighter tone. While still damp, the trees were added using wet-into-wet to create soft definition. I achieved the reflection by wiping out damp paint with a tissue, care being taken to make the widening perspective accurate. The moon was also lifted this way, using a mask – a round hole cut in thick paper. Damp tissue was dabbed into the hole until enough paint had been removed.

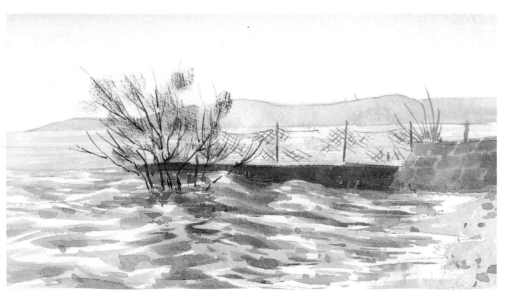

Flooded tamarisk

Watercolour

This flooded tamarisk tree was casting dancing reflections. To create contre jour lighting against strong afternoon sunlight, both sky and water were painted in a pale yellow wash, overlaid with blue where necessary. The light was coming from the back of the picture, so darker reflections and shadows on the waves were added after the background dried. The broken reflection of objects is caused by one side of a wave reflecting the object and the other side reflecting the sky.

Acknowledgements

Patrick and Patricia Carney, Rosemary Bromley,
and my husband Trevor Pitt for his enduring
patience and support.

Index